DUNFERMLINE

THROUGH TIME

Eric Simpson &
George Robertson

AMBERLEY PUBLISHING

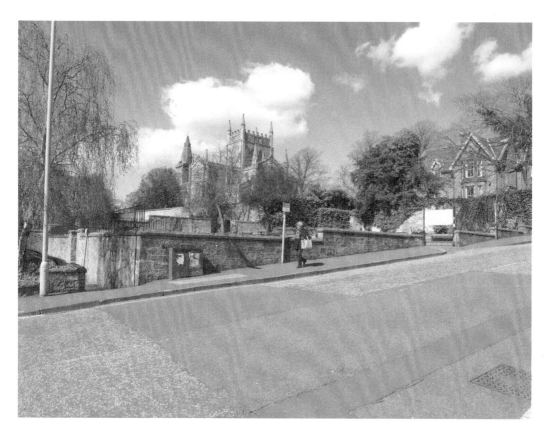

Dunfermline Abbey as seen from St Margaret Street.

First published 2012

Amberley Publishing
The Hill, Stroud
Gloucestershire, GL5 4EP

www.amberley-books.com

ISBN 978 1 4456 0524 1

British Library Cataloguing in Publication Data.
A catalogue record for this book is available from
the British Library.

Typeset in 9.5pt on 12pt Celeste.
Typesetting by Amberley Publishing.
Printed in the UK.

Introduction

In the eighteenth and nineteenth centuries, Dunfermline developed as a significant industrial centre, with linen and coal as the main industries. These are now gone, with service industries largely taking their place. During the middle ages, the town flourished as a seat of royal and clerical power. It was a favourite resort of Scottish monarchs, many of whom chose it as their burial place – most notably King Robert the Bruce. It was the interment there of Queen Margaret in 1093 that led to Dunfermline Abbey being considered to be a particularly holy place. This followed from her being sanctified in 1249. Pilgrims flocked to the abbey to the shrine of St Margaret with the monks and their aides providing the medieval equivalent of a service industry. The abbey continues to be a major attraction with tourists replacing the pilgrims of its medieval heyday.

The sixteenth-century Reformation saw the downfall of the monastic house. Subsequently, the Union of the Crowns in 1603, when Jamie the Saxt became James I of England, brought about the loss of the royal connection. A period of decline then ensued, and only ended with the growth of the textile and mining industries.

The nineteenth-century industrialisation brought losses as well as gains. The advent of the power-loom factories caused the decline of handloom weaving and the impoverishment of many families. Some handloom weavers opted for the factories, thus losing their independence. The Carnegie family, on the other hand, chose emigration and headed for the USA. Andrew Carnegie's financial success there benefited the burgh in many ways. Pittencrieff Park and the creation of the Dunfermline Carnegie Trust were only a few of his many generous gifts to his native town.

A major early twentieth century development was the UK government's decision to build a naval base and dockyard and associated 'new town' at nearby Rosyth. Dunfermline's burgh boundaries were extended to include this new 'garden city'. (A separate Amberley publication by Martin Rogers covers the story of Rosyth.)

The effect of improved communications, most notably the completion of the Forth Road Bridge in 1964, has seen a vast expansion of the eastern suburbs. Nowadays a large part of the population of Dunfermline travels to Edinburgh and surrounding area to find employment.

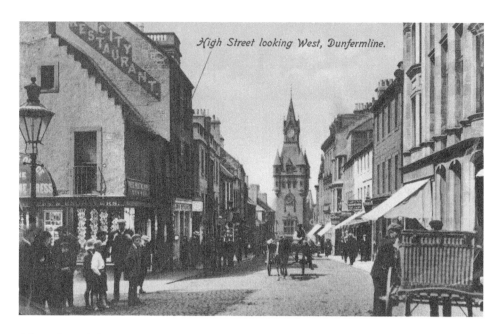

High Street looking West, Dunfermline.

Edwardian High Street

The obvious difference between the two images is the presence of the mercat cross in the contemporary one. The cross, which is partly a Victorian reconstruction, is now situated in its original 1396 position. The corbie-stepped gabled building on the left has fulfilled many different functions.

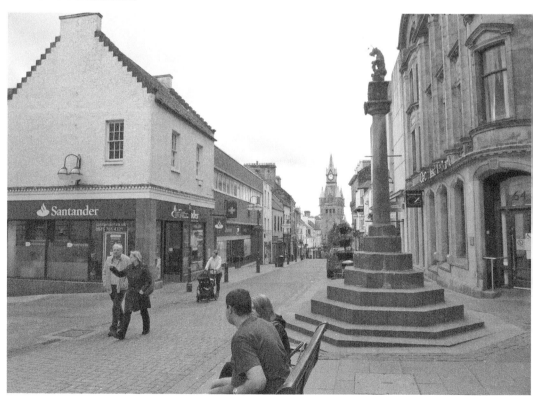

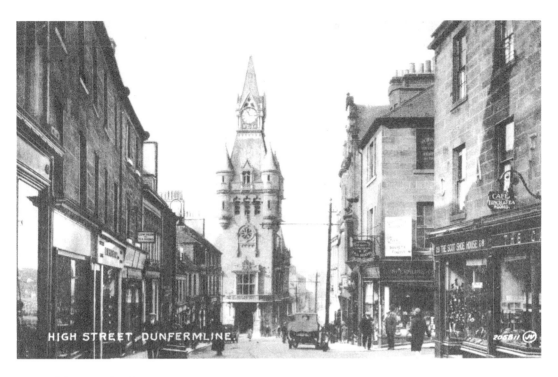

High Street in the 1920s

In this 1928 image we see the tramlines and overhead electric cables for the tramway system introduced to Dunfermline in the late Edwardian period. As can be seen in the modern image, all the buildings on the right side, mostly Co-op shops, have gone.

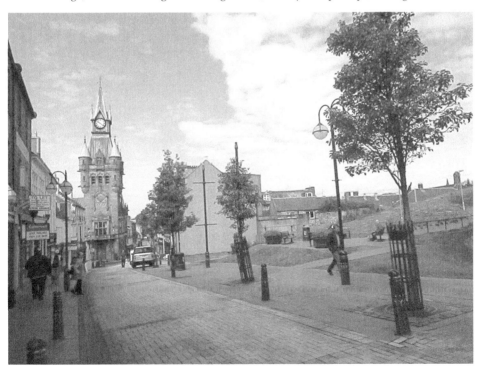

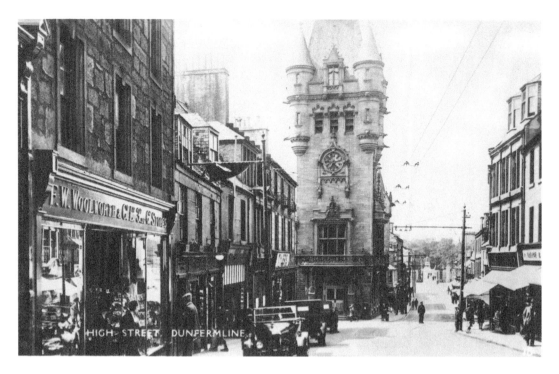

High Street in the 1930s

Woolworth's store, at its original site, was opened in 1922, selling cheap goods nothing priced over six old pennies. On market day, the medieval High Street would have been packed with stalls. The Christmas market is the modern equivalent.

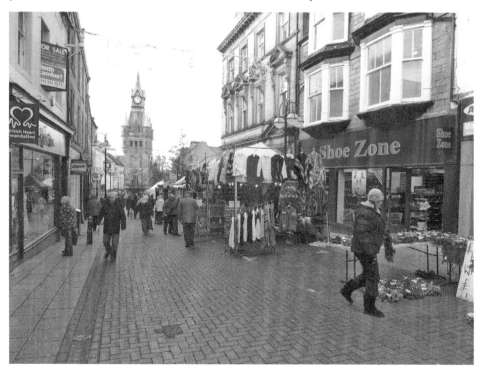

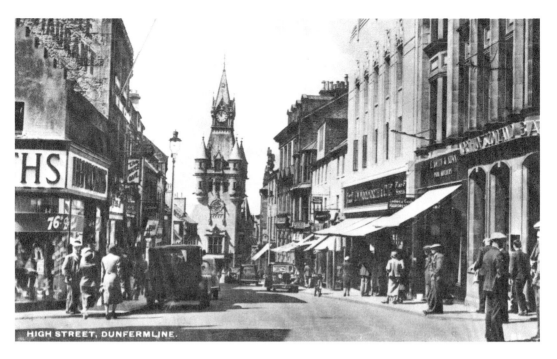

HIGH STREET, DUNFERMLINE.

High Street in the 1940s

In 1939 Woolworth's moved to the opposite side of the street, occupying an art deco building, a style of building strongly contrasting with the Victorian French Gothic of the Toon Hoose, or the City Chambers to give it its more grandiloquent official title.

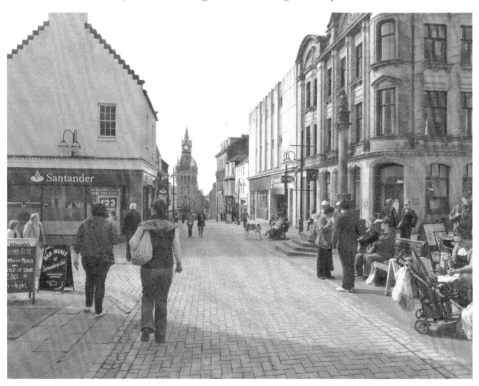

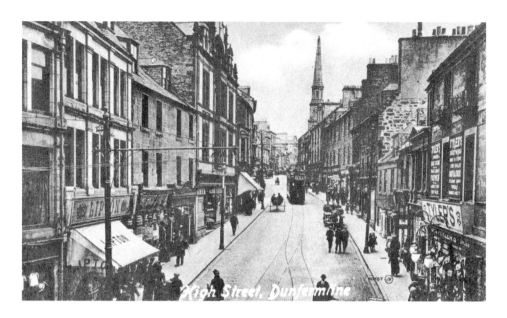

West High Street

Old postcards show the names of multiple shops that were once familiar names on the High Street, as for instance Lipton's grocery on the left side and Tyler's shoe shop opposite. Market stalls and causey setts as seen in the modern image mark a return to old-style ways.

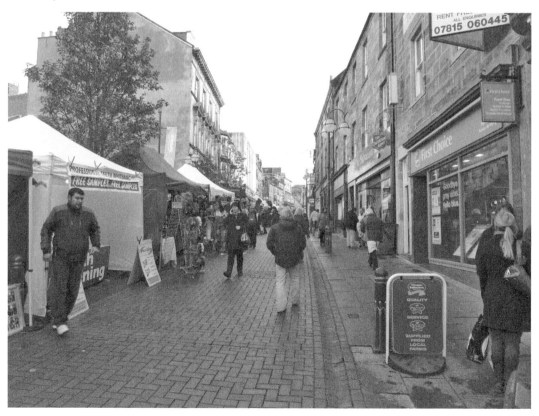

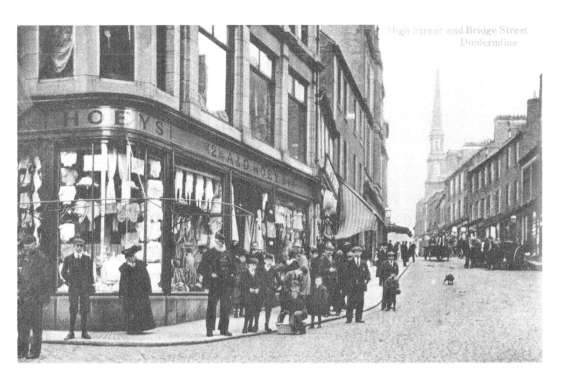

Ladies' Frilly Corner

Retail premises have changed a lot over the last one hundred years. We no longer have such cluttered shop windows as Hoeys', with its display of what appears to be mainly ladies' frilly garments. But the males are strangely more interested in the photographer, just like the young man in the modern image.

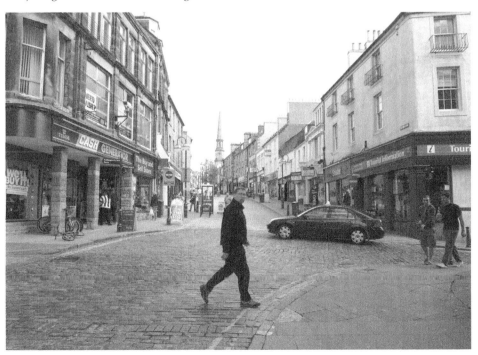

9

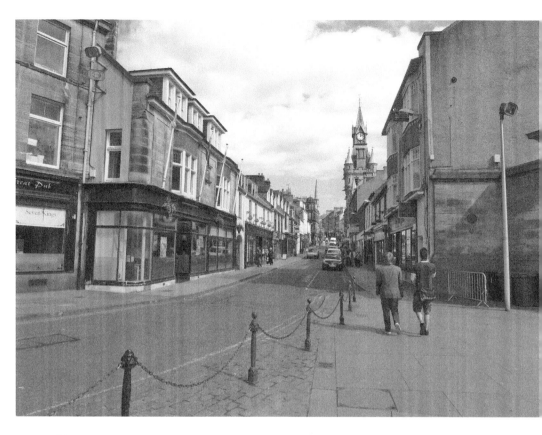

Bridge Street

Comparing old with new, we see that the buildings on the extreme right and left have gone. That on the right was removed to make way for the new Glen Gates. There is a pub now where Fairfield Drapery Stores stood with David Hutton's outfitter's right next door.

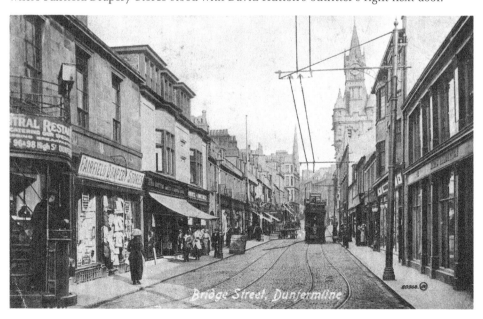

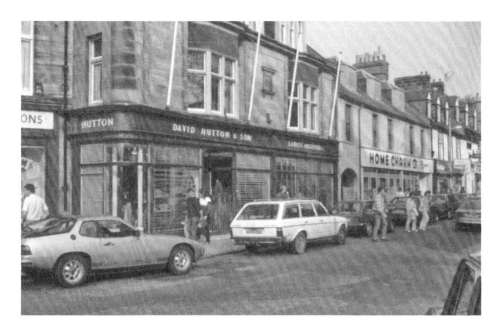

Bridge Street Corner

In 1985 Hutton's ladies' outfitter's was still on the same site, but with expanded premises. The entire corner is now occupied by a large pub chain. This is typical of the way that small family businesses have been lost to high streets everywhere.

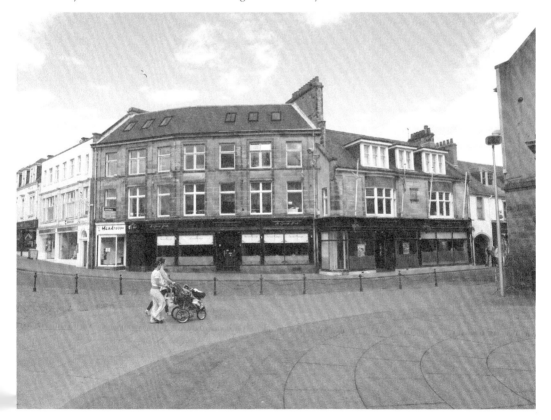

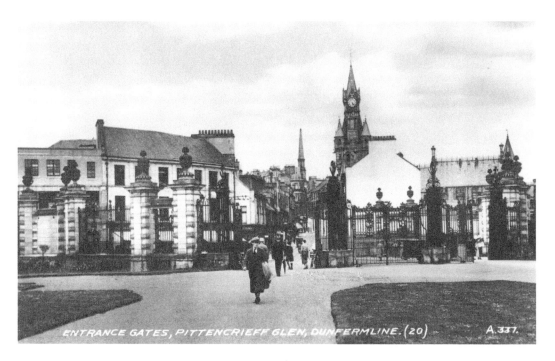

ENTRANCE GATES, PITTENCRIEFF GLEN, DUNFERMLINE. (20) A.337.

Glen Gates

Since 1929 when the Glen Gates were installed by the Carnegie Dunfermline Trust, the gates remain unaltered, unlike the men's style of dress. To facilitate the erection of the gates, a number of properties in Bridge Street and Chalmers Street were demolished by the Trust.

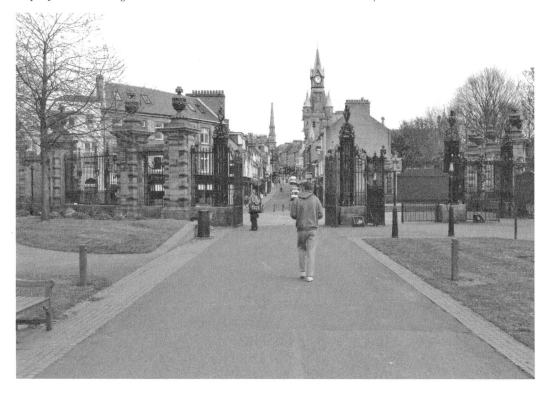

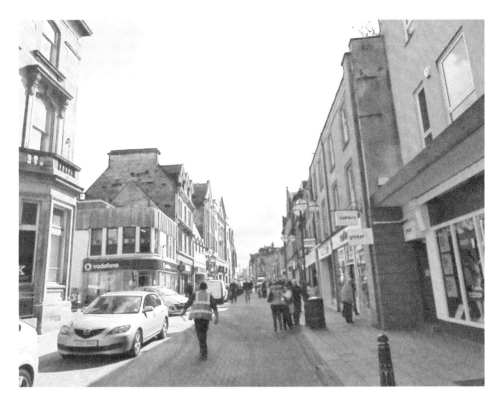

East High Street

Nowadays cars replace the horse-drawn vehicles and hand-carts of former days. The early image shows the High Street in the process of transition with overhead tramway power cables ready for use but no tramlines as yet.

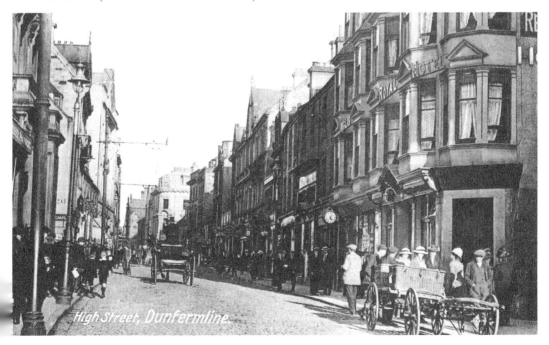

High Street, Dunfermline.

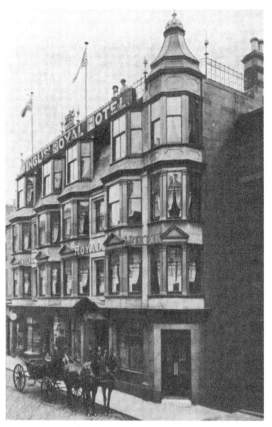

Royal No More

Where the Royal Hotel once stood, a
ladies' outfitter's shop now stands. This
once good quality hotel was demolished
in 1964 to make way for what was then a
supermarket. For an advertisement card,
the image is carefully posed to convey the
impression that this is a high-class hotel.
The smart-topped driver would have
conveyed guests to and from the railway
stations. The coat-of-arms on the roof
also reinforces the message that this is a
quality establishment.

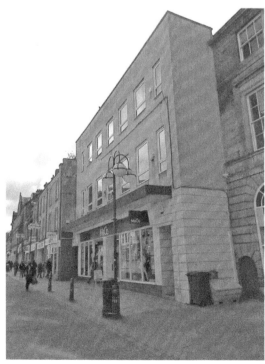

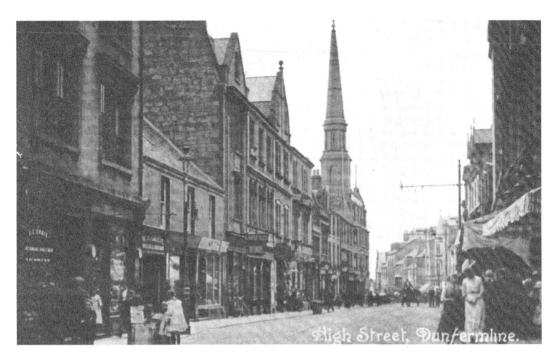

High Street, Dunfermline.

Guildhall Exchanged

The slender tower of the former Guildhall dominates the centre of the High Street. It has been renamed as the Guildhall and Linen Exchange and is now a pub. An AA sun brolly replaces the shop awnings of yesteryear.

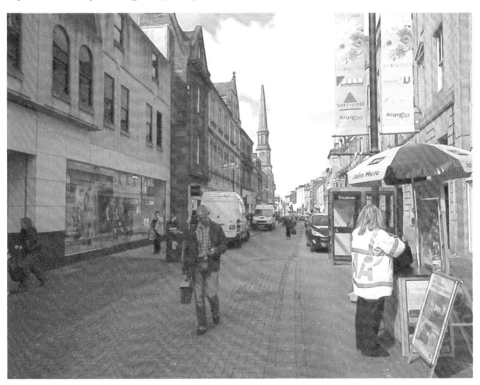

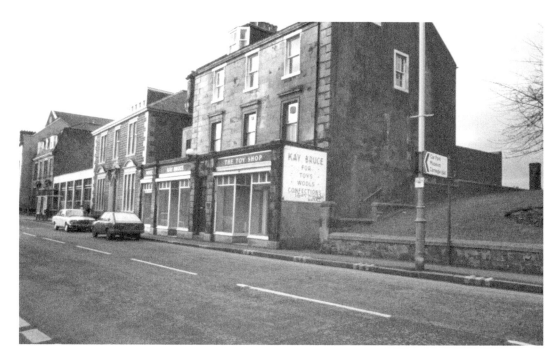

East Port Shops

In the 1980s Kay Bruce sold toys and knitting wool from two adjacent shops. She also had a confectionery shop nearby, which was handily located for the nearby cinema, and also for the Carnegie Hall. Note the original building has been extended on the ground floor to accommodate the shop fronts.

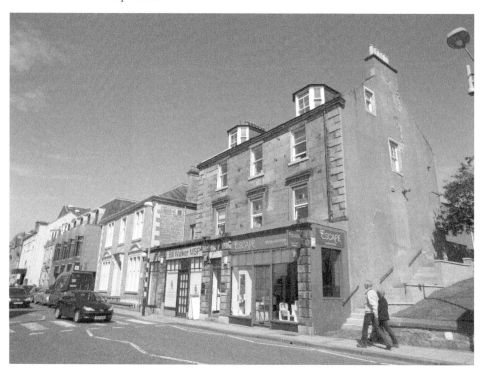

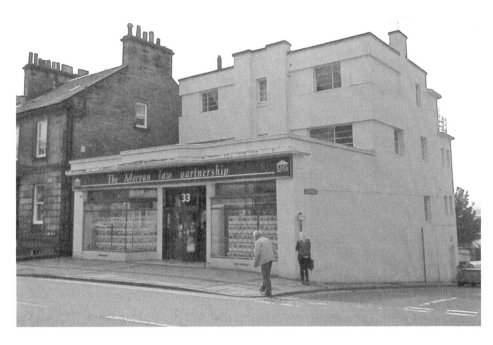

Power for the People?

What is now a solicitor's office was built in 1938 'modern' style, to house an electricity board showroom and offices. The crowd was not there to pay their bills, but to welcome a 1950s American TV personality – Jeannie Carson. In her TV role this Yorkshire lass claimed Dunfermline as her place of birth, giving the town free publicity.

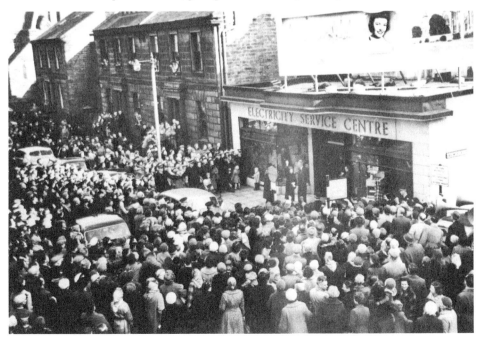

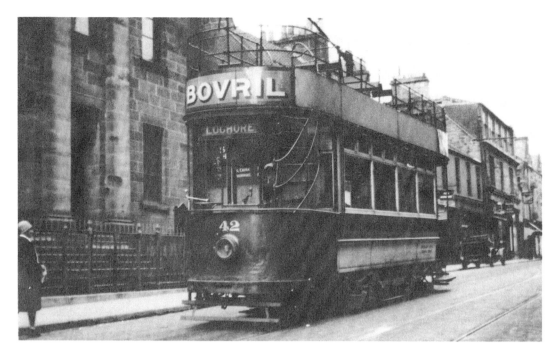

Trams No More

The building on the left of the tram was St Margaret's Parish Church now replaced by a Dunfermline Building Society complex. The first trams, all open topped, were running in Dunfermline in 1909, with the Lochore extension added in 1912. Faced with the challenge of buses, the entire system was closed in 1937.

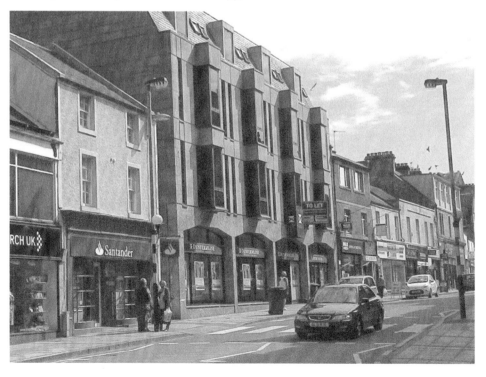

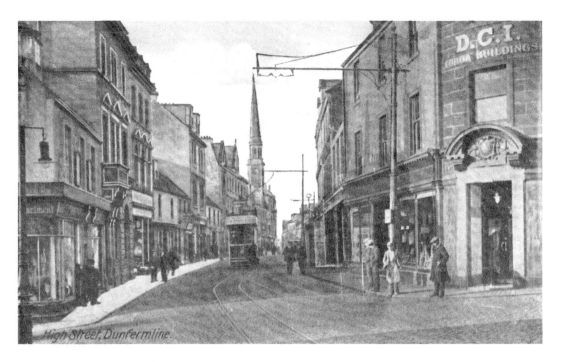

From Co-op to Marks

Dick's Co-operative Institution operated a number of shops in the Dunfermline area. Another popular retail establishment, Marks & Spencer's, now occupies the site. This image has been doctored by the makers, as older versions of the same postcard have some details different.

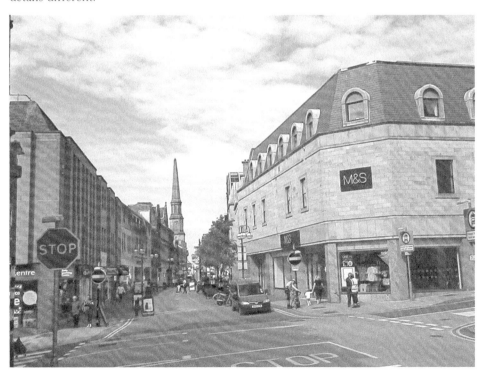

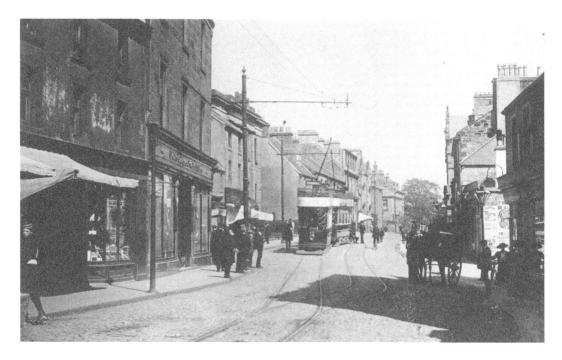

East Port Loop

The buildings on the left have gone with Marks & Spencer's occupying the site. With more greenery and seats for pedestrians, the street is more user-friendly than its Edwardian equivalent. The two trams are on the East Port Loop, one of the places where the lines were doubled to allow for passing.

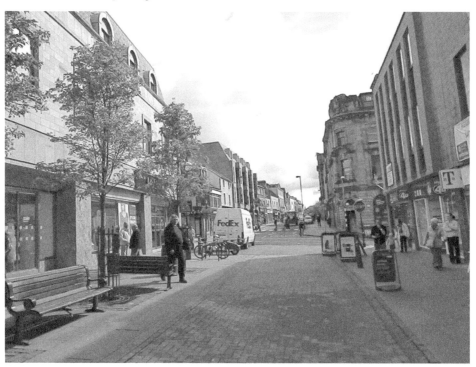

Doon the Kirkgate
Dunfermline City Police had its
headquarters in the Town House, as
evidenced by the sign on the ground
floor. Fraser & Carmichael's Warehouse
occupied the building on the south side of
the Maygate. The site is now empty and
has been grassed over.

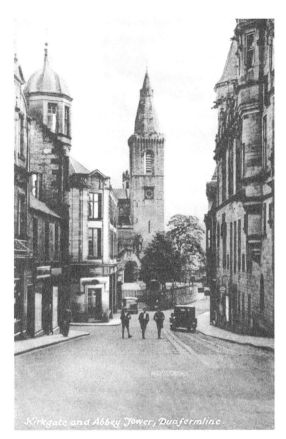

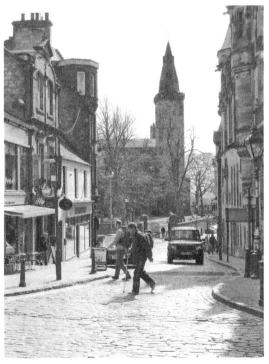

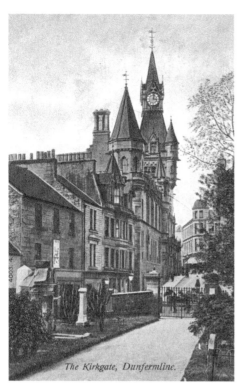

The Kirkgate, Dunfermline.

Up the Kirkgate

Looking up the Kirkgate, the old image shows more detail of the baronial-style City Chambers, completed in 1879. The other buildings on the left are little changed, except for the addition of dormer windows. Have some of the gravestones disappeared?

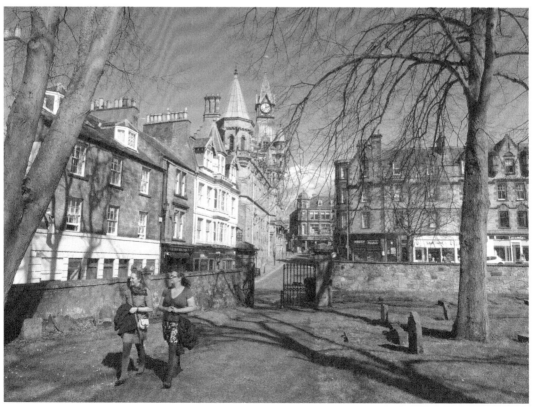

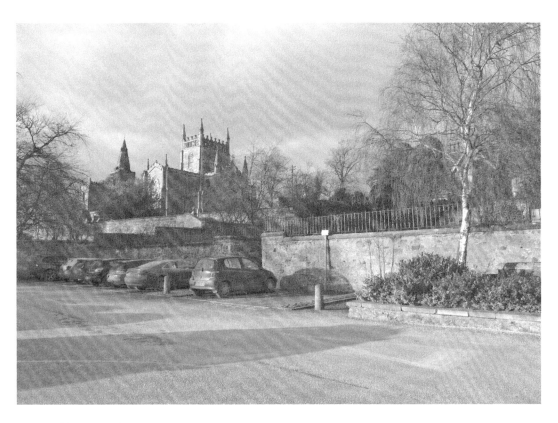

Still a Car Park
Though the bus station has gone (sited there from at least the 1930s), a two-level car park remains on an area once occupied by Henry Reid's linen mill.

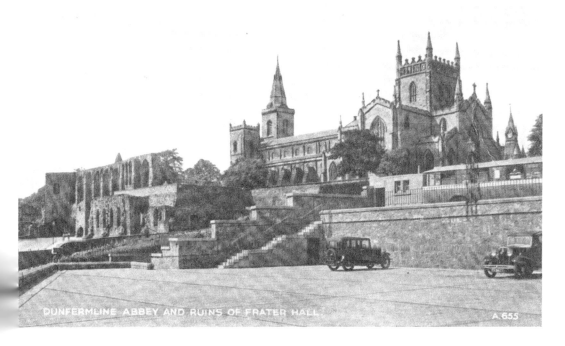

DUNFERMLINE ABBEY AND RUINS OF FRATER HALL.

A 655

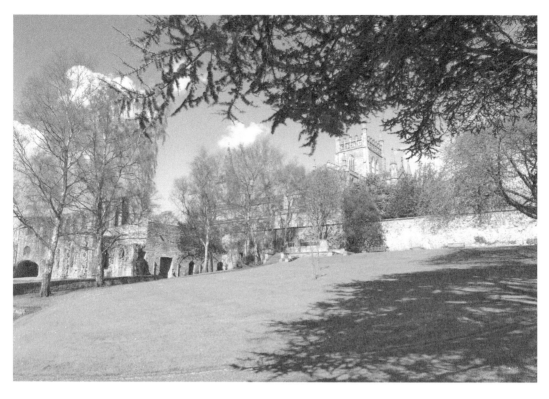

War Memorial Site

Where we now have a grassed area, in the 1930s this was a cultivated area. Was this a market garden? This was once part of the abbey precinct and was once known as Bee Alley Gardens.

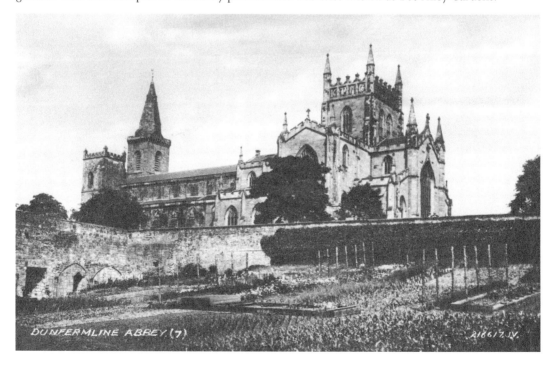

DUNFERMLINE ABBEY. (7)

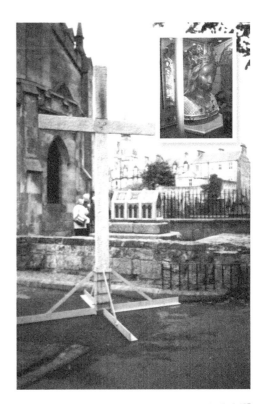

Pilgrimage Site

Over recent years there have been revivals of medieval-type pilgrimages to Dunfermline Abbey and to the remains of St Margaret's Shrine in particular. In the year 2000 a cross and a wooden replica of a shrine were placed at the site for one such revival. Twelve years later the Timeline film crew were filming for the BBC Scotland television series *Grand Tours of Scotland*. For this, presenter Paul Murton interviewed historian Richard Oram on the left. Immediately behind Richard part of the base of the original shrine can be seen. Abbot House provides the back drop. The recreated head of Queen Margaret in the inset comes from Abbot House.

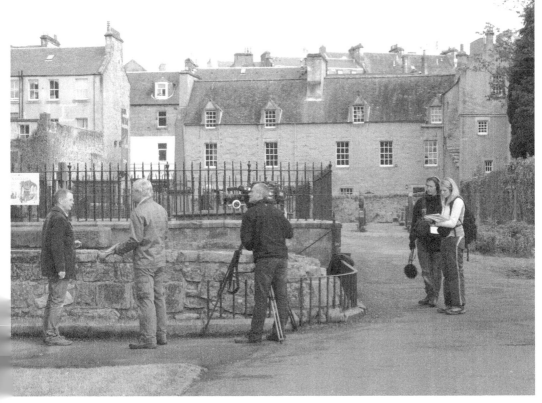

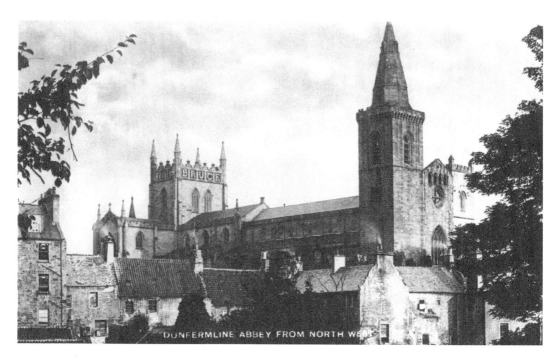

DUNFERMLINE ABBEY FROM NORTH WEST

Where Have all the Auld Hooses gone?

The old dwellings under the lea of the abbey north-west tower were demolished in 1907 and a parapet wall and wrought-iron fencing erected to enhance the appearance of the Glen. The only way to illustrate the scene for the modern image was to photograph it from a different angle.

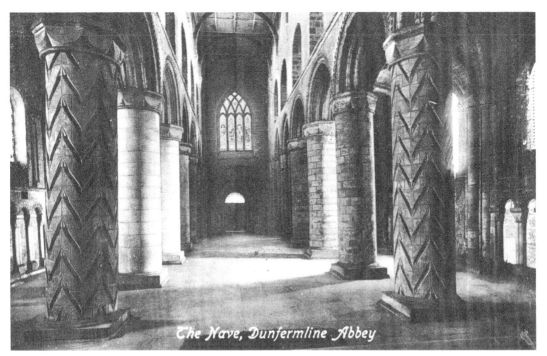

The Nave, Dunfermline Abbey

Abbey Nave

While much of the medieval abbey fell into decay after the Reformation, the nave survived because it was used as the parish church until 1821 when the new Abbey Church was completed for the Church of Scotland. The nave with its fine Romanesque pillars is safeguarded for future generations by Historic Scotland.

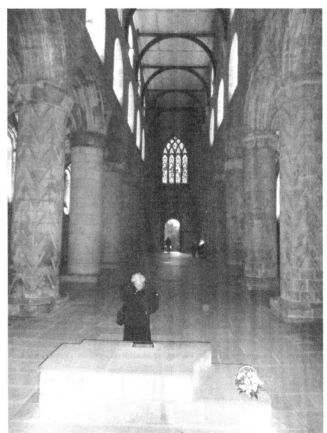

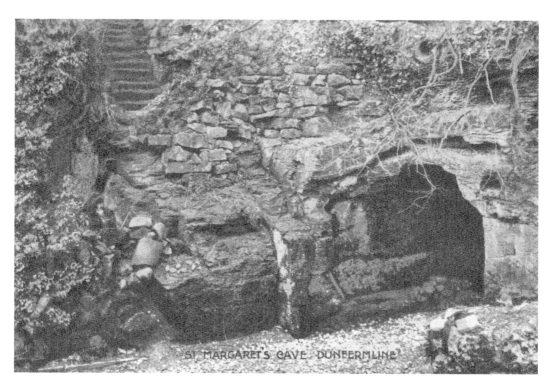

St Margaret's Cave

Now in the corner of a car park, St Margaret' Cave is the place where Queen Margaret is said to have gone for private prayer. It is now a visitor attraction administered by Fife Council. In the background is the Glen Bridge.

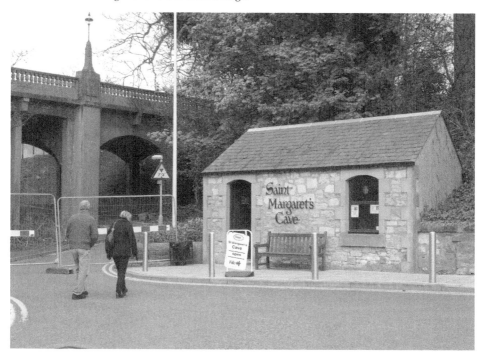

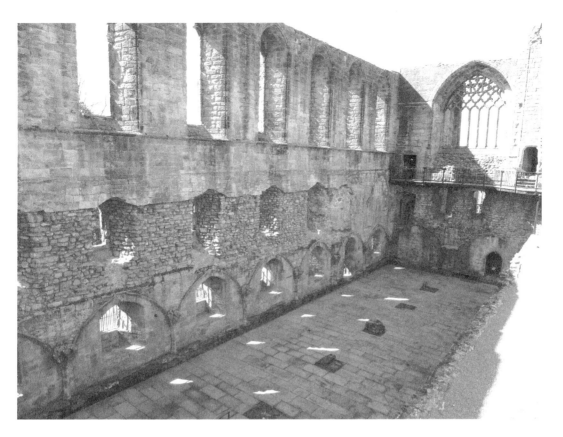

Monks' Refectory

This view of the monks' refectory, or frater, is much changed from the old. In the 1920s the then floor was excavated, thus lowering it to the present level. As with the nave and the palace, the dining-hall of the monks of old is now under the guardianship of Historic Scotland.

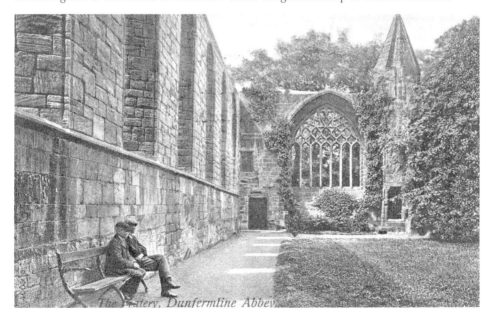

The Fratery, Dunfermline Abbey

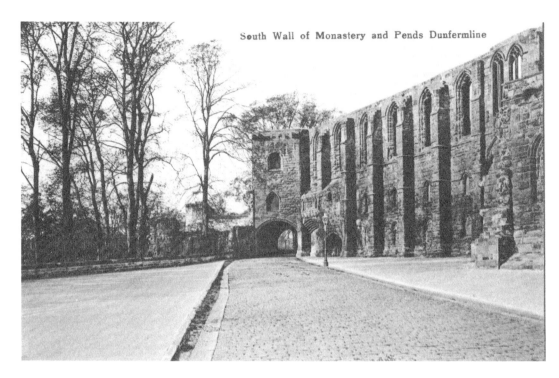

St Catherine's Wynd

The exterior of the refectory and abbey gatehouse presents a striking image as seen from the south. This was a replacement for the original building badly damaged after being occupied by Edward I of England in the winter of 1302–3.

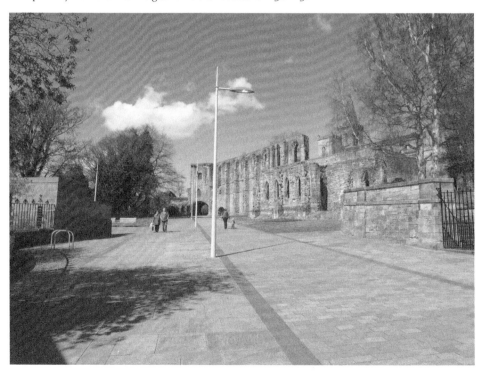

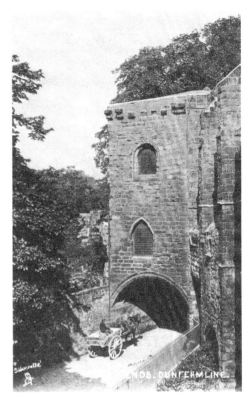

The Pends

Both images, old and new, of the Pends, or gatehouse, have been taken from the same place – the Abbey Kirkyard. As a gateway to the abbey precinct, the now pedestrianised Pends was for long an important thoroughfare in the town.

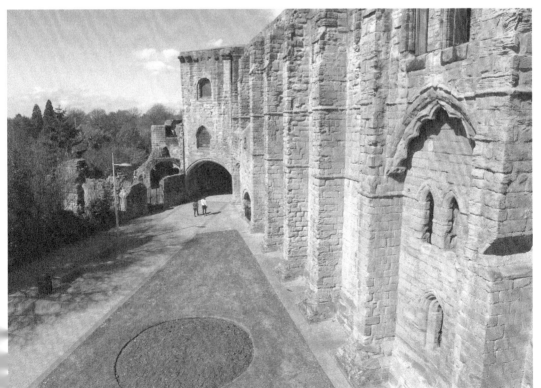

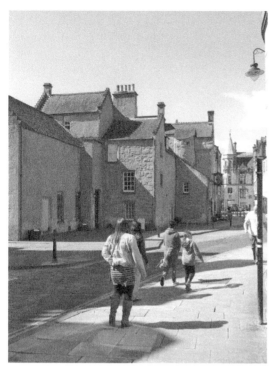

Abbot House

After a chequered history, Abbot House, or the Pink Hoose as it is affectionately known locally, is now an excellent heritage centre run by Dunfermline Heritage Trust. It was painted pink because Historic Scotland reckoned that would have been the original colour. As can be seen in the older image, the streets of the Auld Grey Toun were surfaced with causeys.

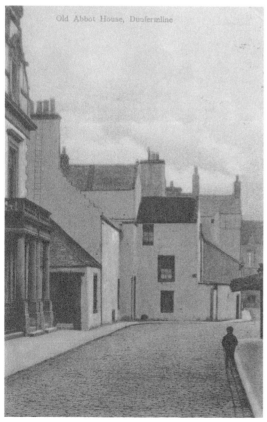

Old Abbot House, Dunfermline

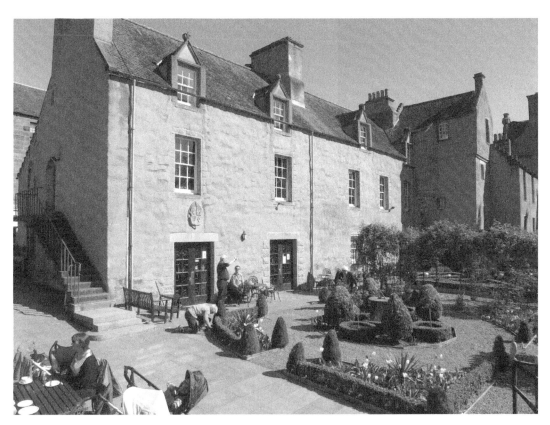

Abbot House Gardens

The present aspect of the Abbot House gardens
illustrates how horticultural fashions change.
Nowadays, gardeners often try to reconstruct the
layout of past centuries. In this case, the garden at
the rear of the Pink Hoose is a part-reconstruction
of the herb garden which would have existed
in the seventeenth century. A team from the
Beechgrove Garden BBC Scotland TV programme
worked on the garden in the early stages.

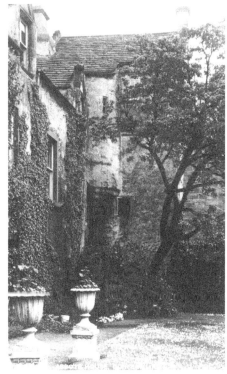

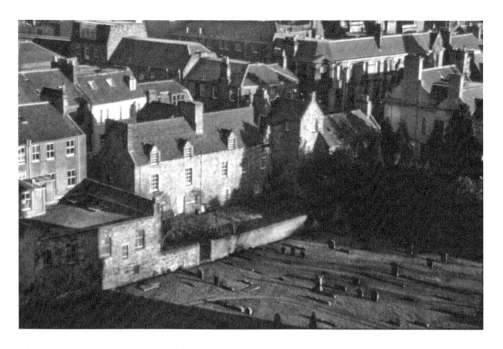

Abbot House Without and Within

The tower of Dunfermline Abbey provides a good vantage point for viewing Abbot House seen in its pre-Pink Hoose days. When the interior was being adapted as a heritage centre, Alasdair Gray, noted writer as well as artist, decorated the walls with images of Dunfermline people, past and present, including former Provost Margaret Miller, singer Barbara Dickson, and ballet dancer Moira Shearer. Out of view is Jock Stein, once the Pars' manager.

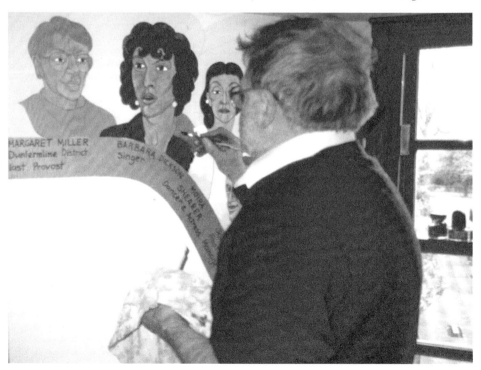

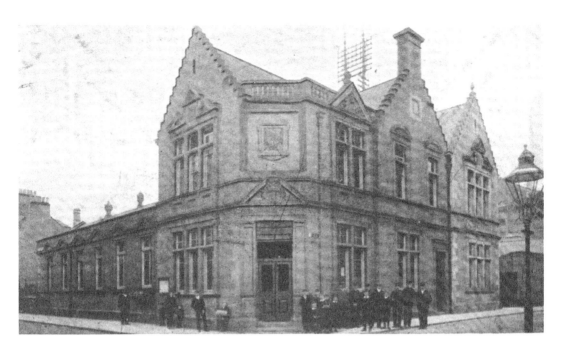

Still a Post Office

Completed in 1890, the post office, at the corner of Queen Anne Street and Pilmuir Street, surprisingly for these days is still in use as a post office. Complete with a shop, it now provides a wider service to the public. Through its mixture of classical-style pediments and crow-stepped gables, it can be described as Scottish Renaissance.

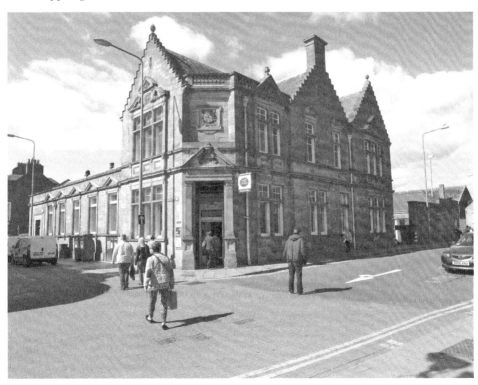

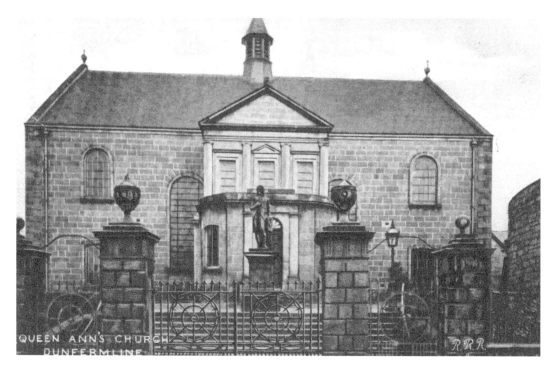

Erskine Kirk

What became the St Andrew's-Erskine Church in Queen Anne was built for a secession congregation in 1800. There have long been controversies as to the future of the currently empty Kirk. The statue in front of this dominating building is of the Revd Ralph Erskine, a notable preacher in his day.

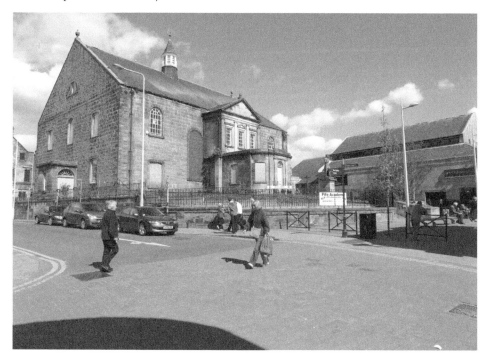

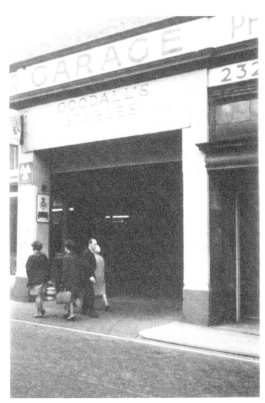

Goodall's No More

Goodall's garage was another notable building in Queen Anne Street. As the inscription above the main entrance shows, Goodall's had its origins in the days of horse-drawn vehicles. It was demolished in 1985 when the Kingsgate Shopping Centre was built.

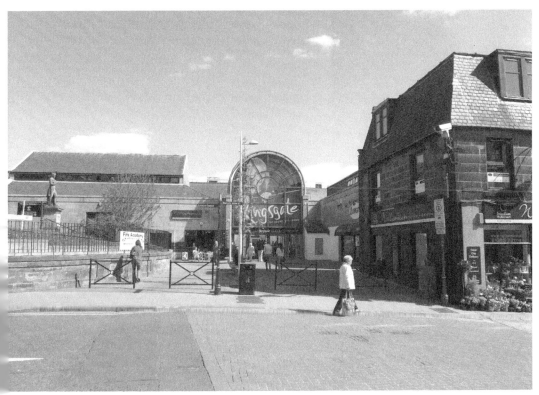

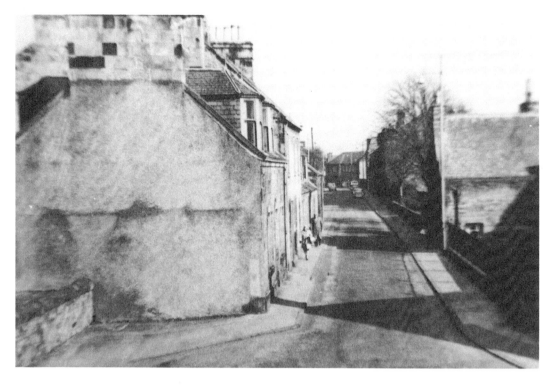

Priory Lane

Between the 1940s and the present day, there have been vast changes in Priory Lane. The dwellings on the left have gone and the street corner much widened. The name Priory reminds us that this was once the southern boundary of the abbey precinct.

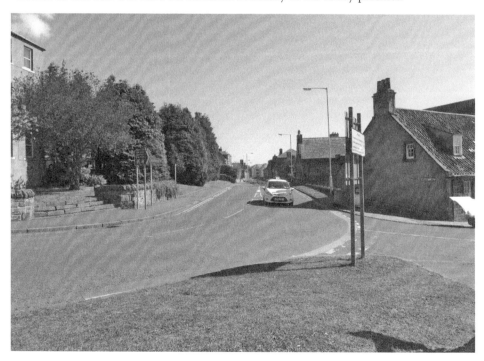

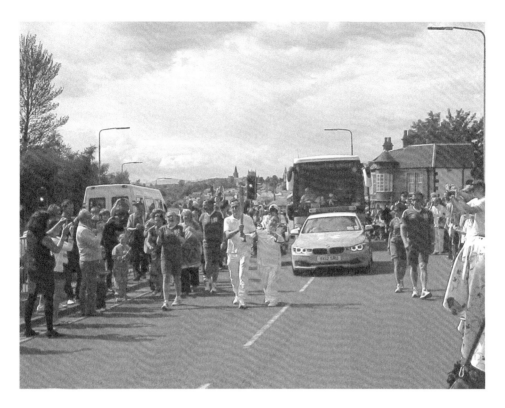

Outdoor Attractions

Crowds always come out when big shows hit the town. In 2012 it was the arrival of the Olympic torch that got an enthusiastic response when passing the Cottage Inn. Around sixty years ago it was elephants of Billy Smart's Circus making their way along Inglis Street that attracted the attention of photographer David Lloyd.

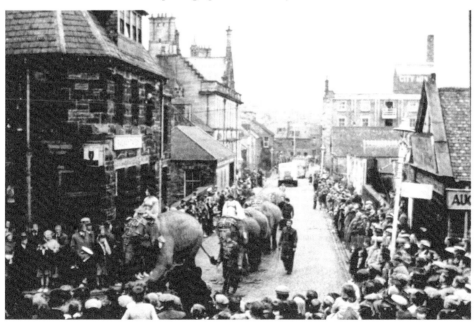

Campbell Street
Photographed in 1985, Young's Garage
with its entrance in Campbell Street, like
Goodall's, was once a well-known business
in the town. With Young's Garage also gone,
houses now stand on the site. The big lum
of the former Victoria linen works of 1876
remains, though somewhat truncated.

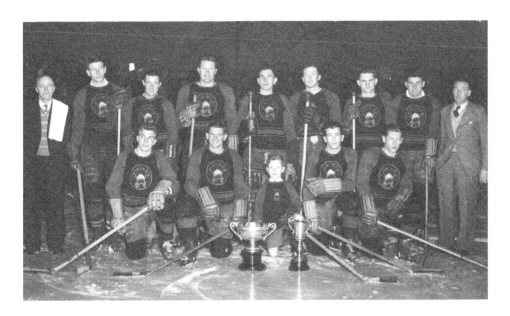

Dunfermline Vikings

Dunfermline hosted a successful ice hockey team in the years between 1939 and 1955. The rink was closed in 1955. For a number of years the building was used for storage and workshop by the South of Scotland Electricity Board. It was later demolished to make way for housing. The team was known as the Vikings. A Viking head in mosaic form was a feature of the entrance hall. Fortunately saved when the building was demolished, the head was retained and is now displayed on the wall of a sports hall of the refurbished Carnegie Leisure Centre in Pilmuir Street.

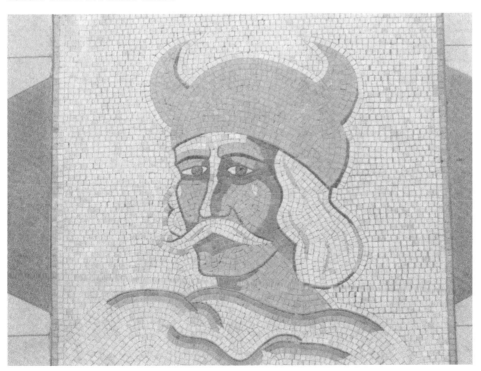

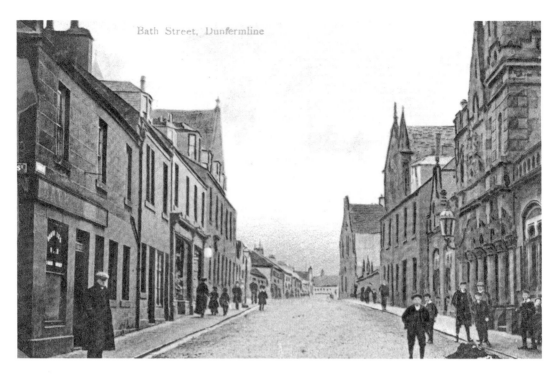

Pilmuir Street

The first Carnegie Baths opened in 1877 were built in School End Street, later Bath Street and now Pilmuir Street. This was Carnegie's first gift to Dunfermline, for which he was granted freedom of the burgh. It was demolished in 1927.

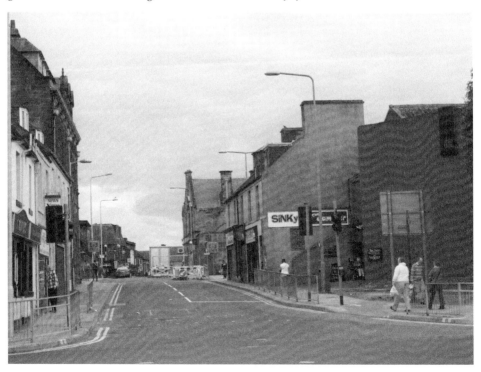

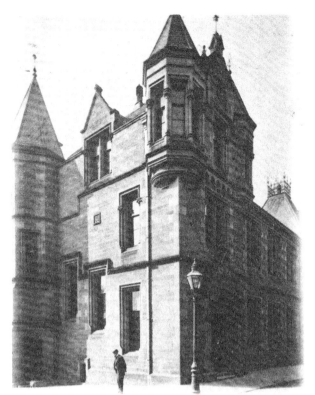

Carnegie Library
Opened in 1883 by Lord Rosebery, this library in Abbot Street was the first of the very many library buildings that Andrew Carnegie donated in the English-speaking world. It has been extended twice to date; the first addition is shown in the new image.

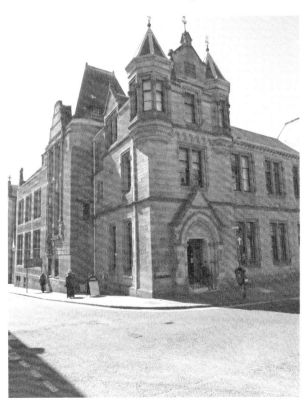

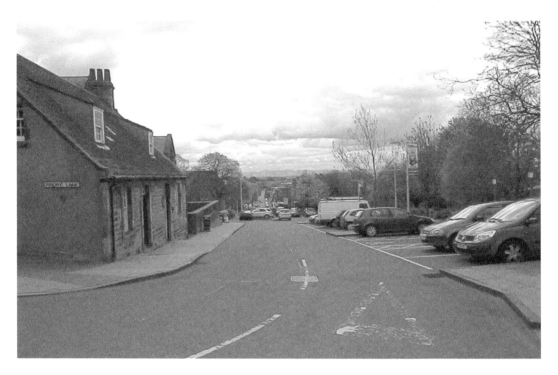

Carnegie's Birthplace

Born in a humble weaver's cottage in Moodie Street in 1835, Andrew Carnegie went on to be one of the world's richest men. The Carnegie family occupied the nearer part of the cottage only, which has been transformed into a museum. The two-storey building has been replaced by a Memorial Hall, and both it and the museum are open to the public free of charge.

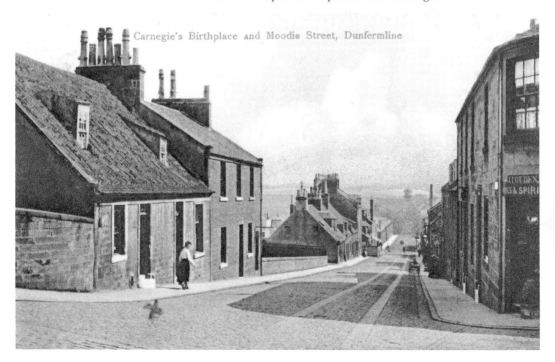

Carnegie's Birthplace and Moodie Street, Dunfermline

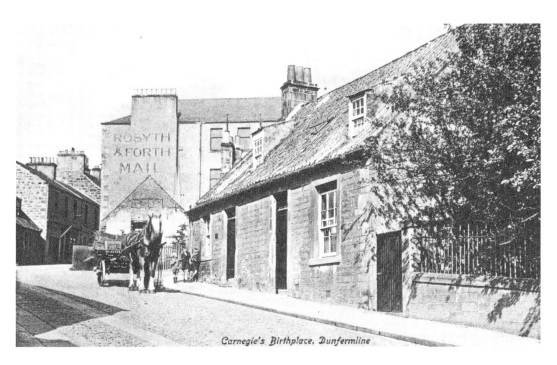

Carnegie's Birthplace, Dunfermline

Old Moodie Street

Here we see the Carnegie Birthplace in the early 1920s after the removal of the two-storey building and the construction of the Memorial Hall. The hall which we see in the modern image was opened by Carnegie's widow in 1928.

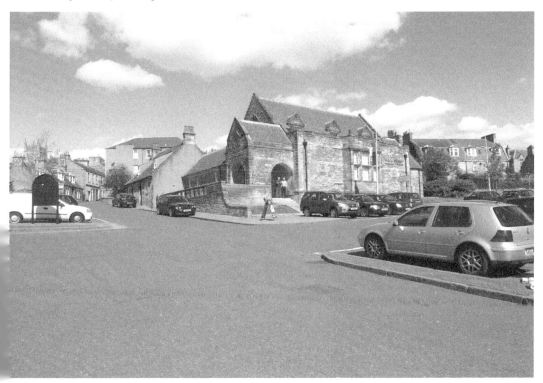

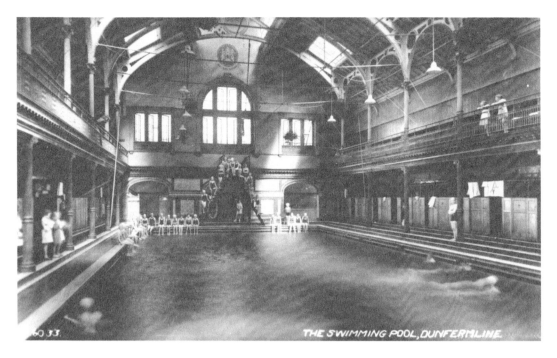

THE SWIMMING POOL, DUNFERMLINE.

Time for a Dook

The new Carnegie Baths were opened in 1905. Recently modernised as part of the Carnegie Leisure Centre, the modern architects have retained, as we see in the modern image, the original iron roofing struts and general layout.

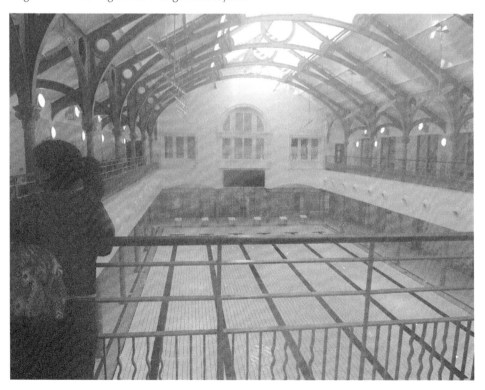

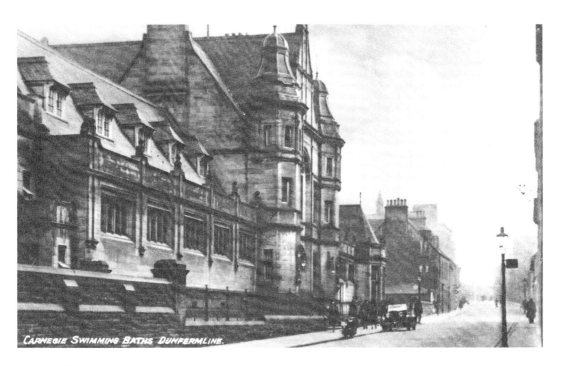

CARNEGIE SWIMMING BATHS DUNFERMLINE.

Baths Exterior

The exterior of the original building in Pilmuir Street remains unchanged. The architect was the wonderfully-named Hippolyte J. Blanco of Edinburgh. In the newer image, we see on the left the recent extension.

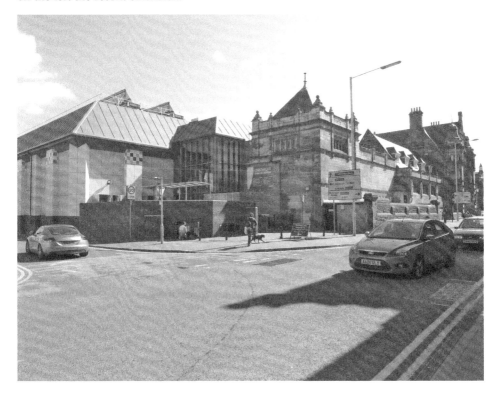

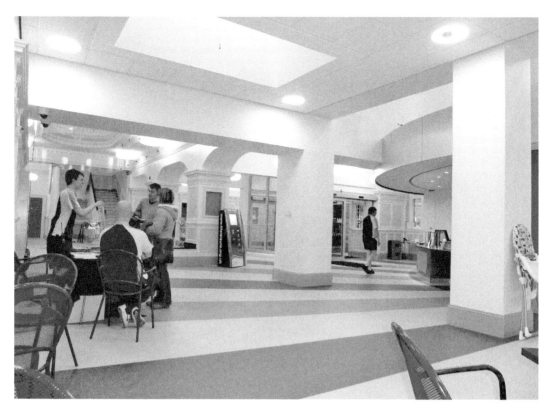

Where Have All the Plants Gone?

The present entrance hall of the Carnegie Leisure Centre now houses a cafeteria but the mosaic floor has gone. It is less fussy than the old but could do with some greenery all the same.

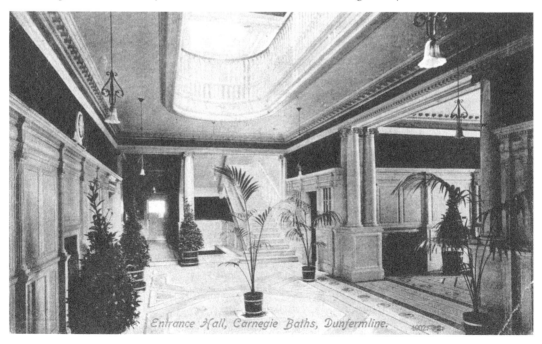

Entrance Hall, Carnegie Baths, Dunfermline.

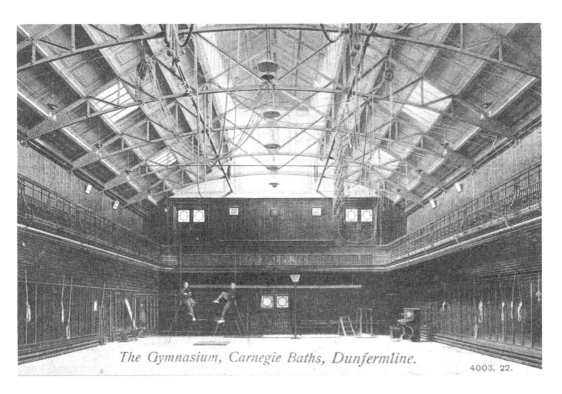

The Gymnasium, Carnegie Baths, Dunfermline.

4003. 22.

Physical Jerks

There is an immense contrast between the two images, firstly, in the kinds of equipment used and, secondly, in the interior layout. This modern gym utilises only part of the top level of the original gymnasium.

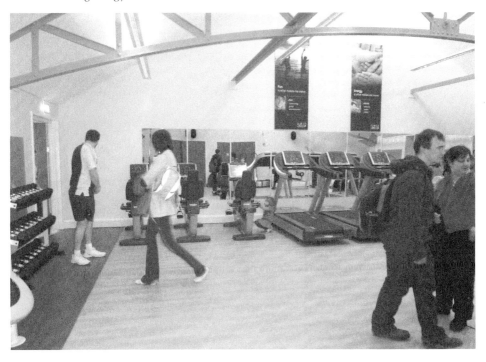

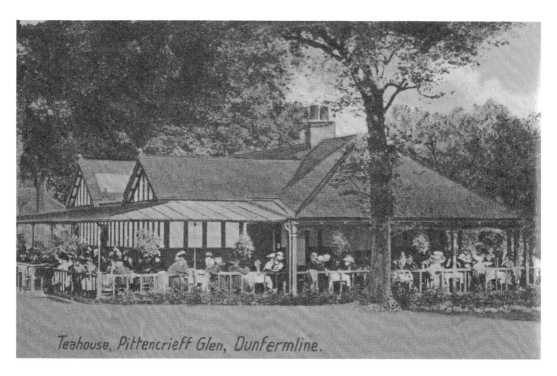

Teahouse, Pittencrieff Glen, Dunfermline.

Time For Tea

There has been a series of teahouses on this location, the most recent shown in the process of alteration. The original Tudor-style building, erected in 1904, was twice extended before being replaced by the present cafeteria in 1927.

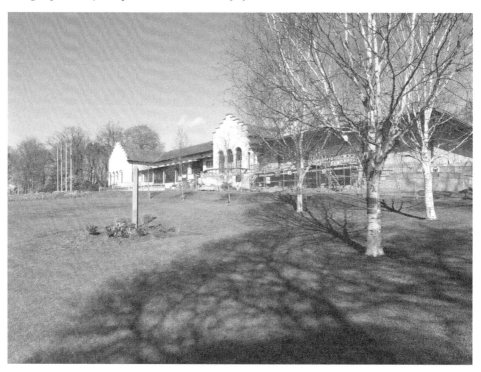

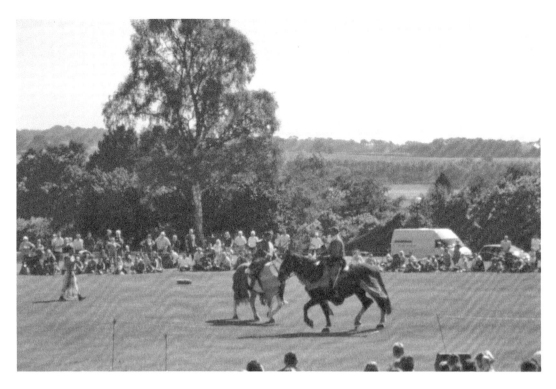

Leisure in the Glen

Knights' jousting is one of the newer attractions in Pittencrieff Park, or the Glen to give it its popular name. Some of the simpler pleasures of yesteryear remain, but listening to the band is not one of them. Even the bandstand has gone, replaced by a car park.

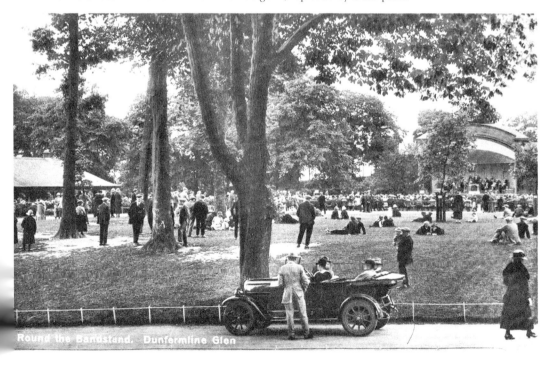

Round the Bandstand, Dunfermline Glen

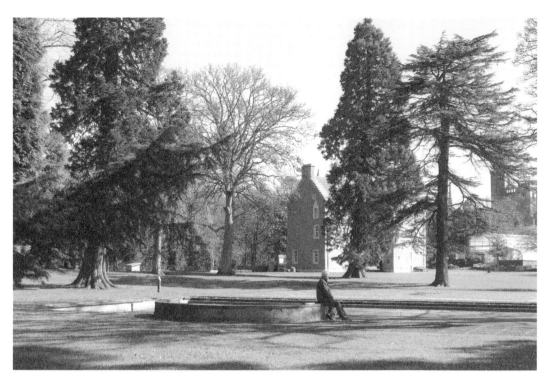

Where Have all the Bairns Gone?

Sadly Health and Safety regulations have meant that most paddling pools like this one in the Glen have fallen out of use. In 1950 in the pre-computer age, children were content with simpler pastimes.

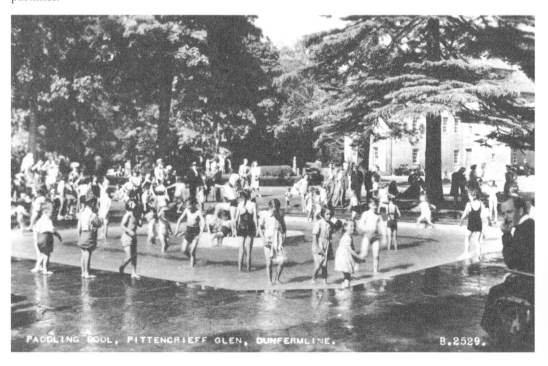

PADDLING POOL, PITTENCRIEFF GLEN, DUNFERMLINE. B.2529.

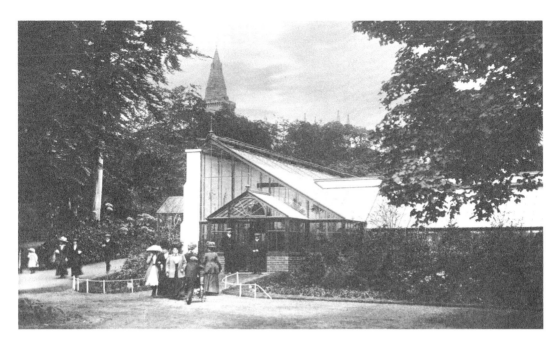

The Greenhouses
The image of the Conservatory, as photographed in 1909, shows a very different style of building from the present.

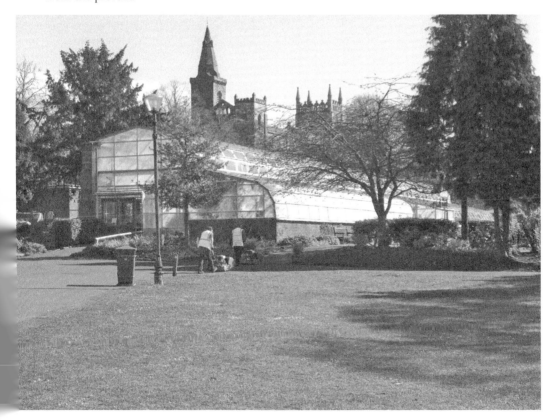

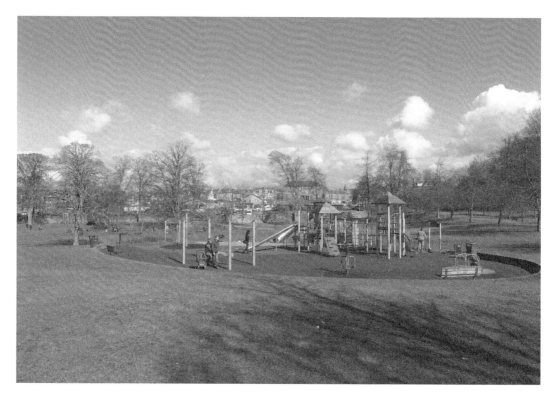

Young Swingers

Modern play areas are more complex with more varied pieces of equipment than the simple wooden swings of Edwardian times. Some of the swings then were reserved for girls under fourteen years of age, and the others for boys. The Squirrels' Cage in the older image no longer exists.

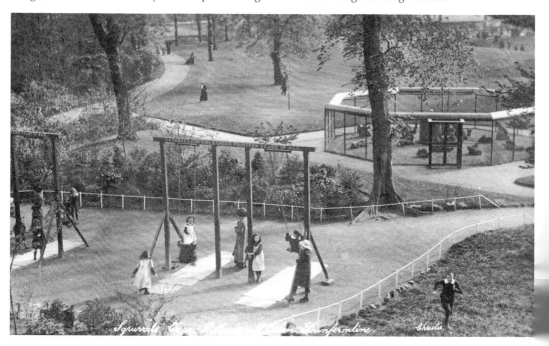

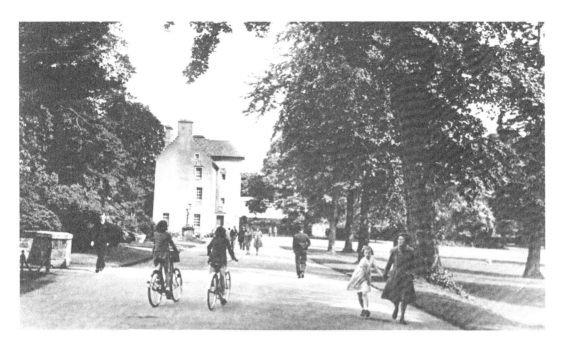

Pittencrieff House

The early seventeenth-century Pittencrieff House came with the estate when it was purchased by Andrew Carnegie in 1902. The estate was gifted to the people of Dunfermline together with an endowment fund. It is now a museum run by Fife Council.

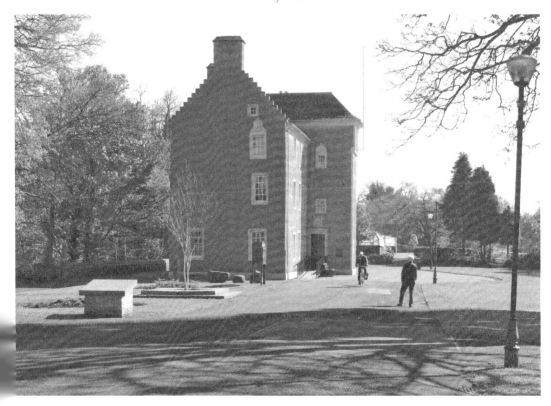

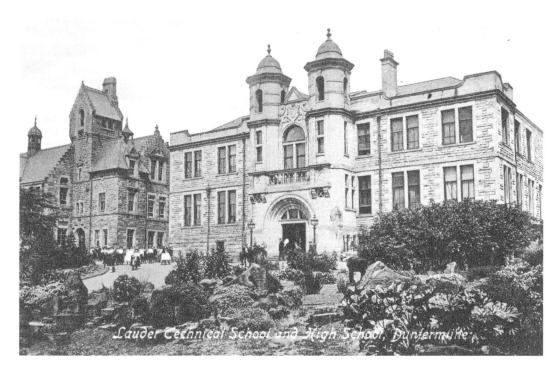

Lauder Technical School and High School, Dunfermline

Lauder Tech

The Lauder Technical College, another gift to the town from Andrew Carnegie commemorated his uncle George Lauder. With a new college, now bearing Carnegie's own name, elsewhere in the town, the old building like the former High School next door has been converted into flats.

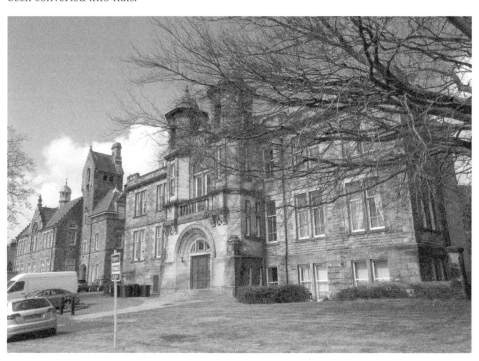

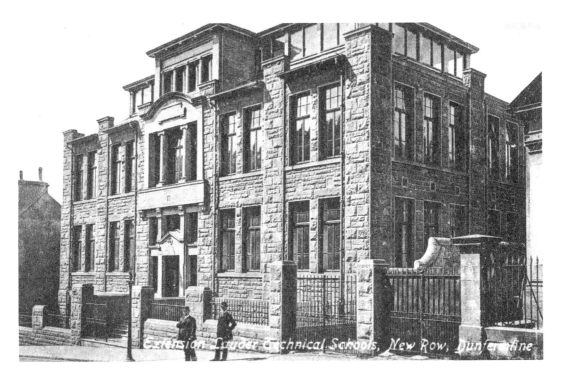

Red Tech

Its red sandstone exterior rather obviously accounts for the popular name bestowed on this 1910 extension to the Lauder College. This is yet another former public building that has been converted into flats.

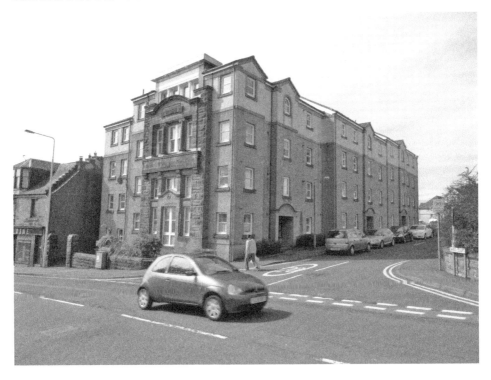

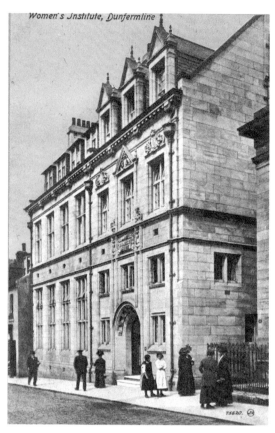

Women's Institute
Louise Carnegie, Andrew's wife, opened the Women's Institute in 1912. It included a social parlour and reading room, and was open to all women and girls of Dunfermline for a nominal fee. It is now a disco!

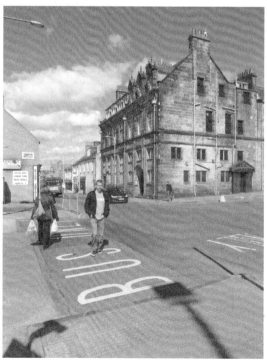

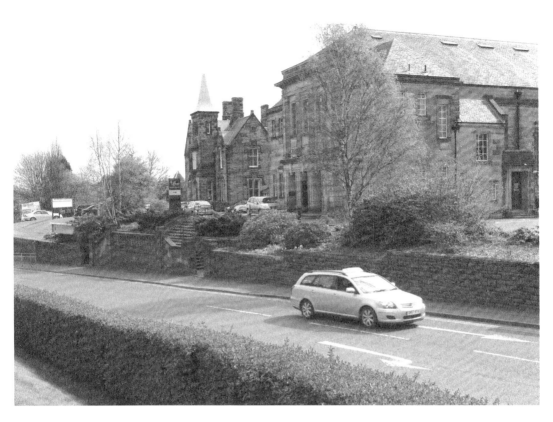

The Real Carnegie Hall

Opened in 1937, this fine hall forms part of a complex which incorporates the Victorian Benachie House on the left which serves as the Music Institute. Funded originally by the Carnegie Dunfermline Trust, the entire complex was sold to Dunfermline Town Council in 1965 and is now administered by Fife Council.

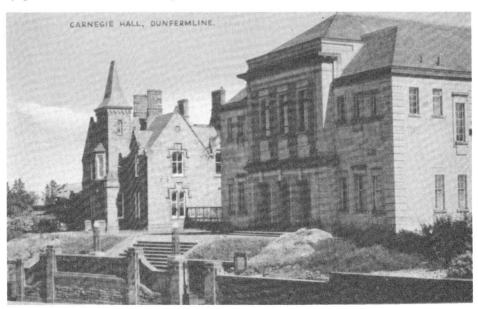

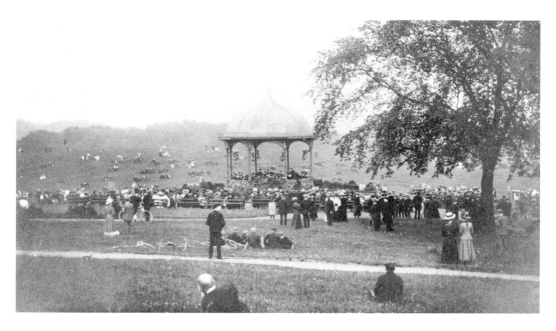

Listen to the Band

The late Victorian Public Park was the town's first 'lung for the workers'. The 1888 bandstand, manufactured by Glasgow's famous Saracen Foundry, was gifted to the town by Louise Carnegie. Sadly, listening to the band whether in the Park or in the Glen is no longer fashionable.

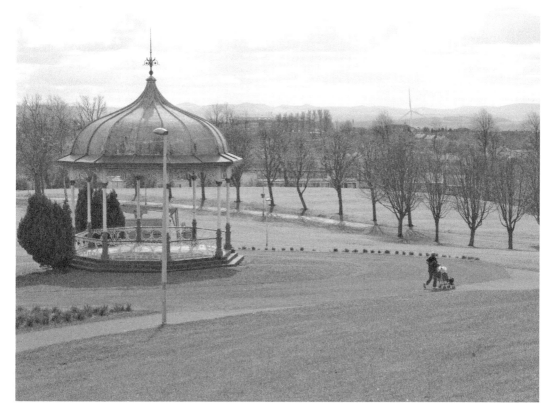

ERSKINE BEVERIDGE & Co., Ltd.

Manufacturers of Household Linens

Factories:

Dunfermline
Cowdenbeath
Ladybank
Dunshalt

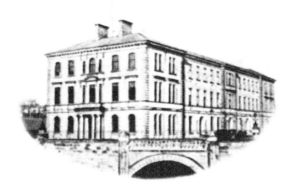

Warehouses:

London
Manchester
Montreal
New York

St. Leonards Warehouse, DUNFERMLINE

Twilight of an Industry

The old advertisement for Erskine Beveridge's household linens reveals the world-wide range of the Dunfermline damask linen industry in its Victorian and Edwardian heyday. The more recent image was taken in 1989 inside the St Leonard's works at the tail end of this once great industry when it was just a fragment of its former size. The main factory buildings were demolished in 1990, but the prestigious office and warehouse building of 1851 has – surprise, surprise – been converted into housing as Erskine-Beveridge Court.

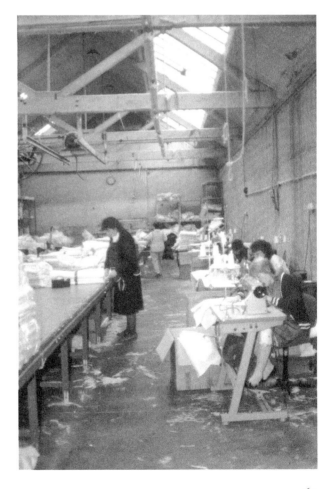

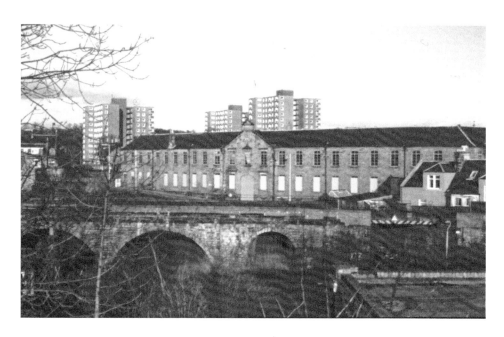

Castleblair Works No More

In early 1984 the Castleblair linen mill was photographed from the south with the old railway bridge in the foreground and the Broomhead flats behind. Later in the same year they were snapped in the process of demolition. This time we are on Foundry Street.

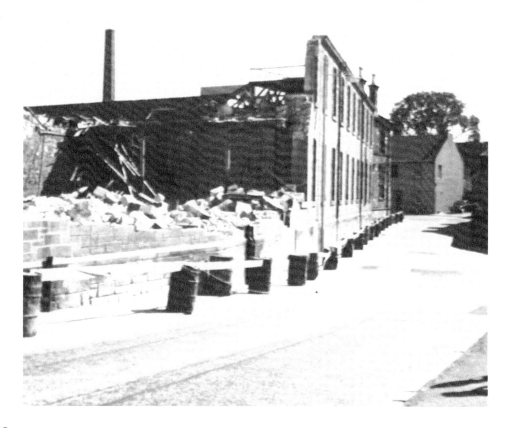

Where Have all the Mills Gone?

With the decline of linen manufacturing and the subsequent silk industry, the building that was once the Canmore works filled different roles as garage and then as Thomson's World of Furniture. In March 2011 we see once again the process of demolition to make way for yet another Tesco supermarket.

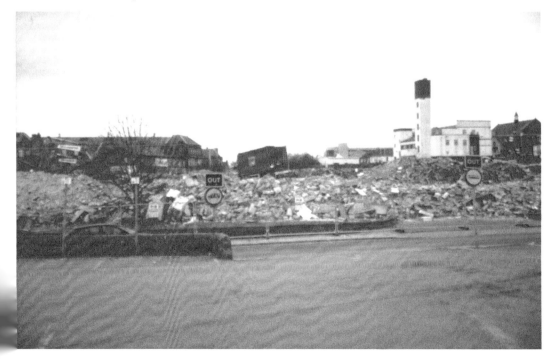

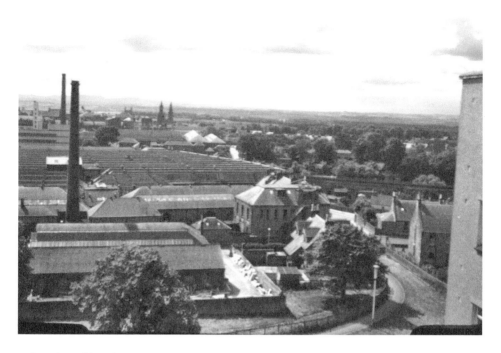

Industries Old and New

Here we have different aspects of industrial Dunfermline. In 1971 the view to the south from the Broomhead flats illustrates how the old coal-powered based industrial belt dominated that part of the town. Contrast this with the present day image taken from Letham Hill, Dalgety Bay, which shows the new industrial area to the south of the town dominated by FMC Technologies' wind turbine.

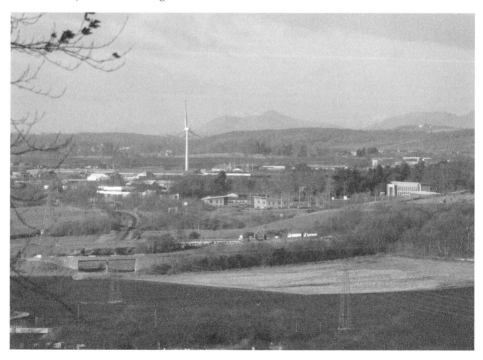

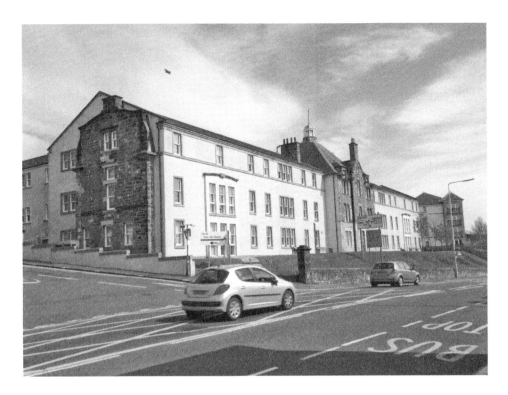

Cottage Hospital

The building of the Queen Margaret Hospital made the former Dunfermline and West Fife Hospital redundant. The site was then used for Fife Council offices but the new structure managed to incorporate part of the original building, which started life n 1894 as a small cottage hospital.

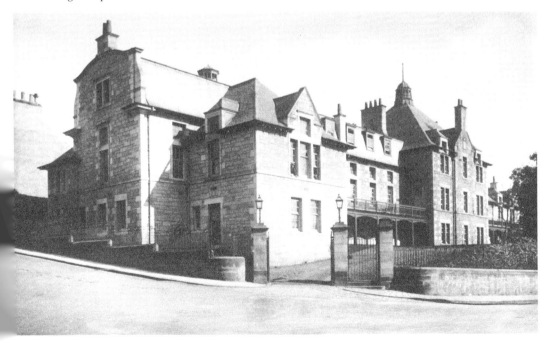

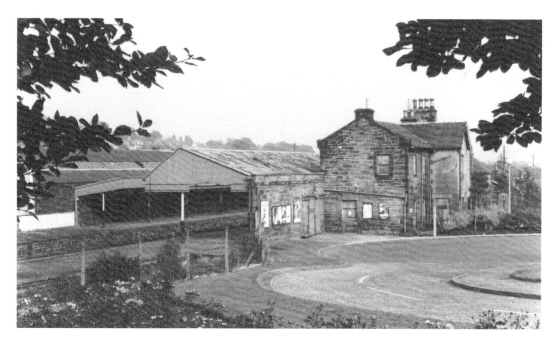

Upper Station

This station dates back to 1850 when the railway first came to Dunfermline. When the Queensferry line was constructed in 1877, the station, here snapped in 1986, had to be renamed as the Upper. After demolition, the site was occupied by Carnegie Drive Retail Park, part of which is shown in the more recent image. The crowd in it was viewing the arrival of the Olympic Torch on 13 June 2012.

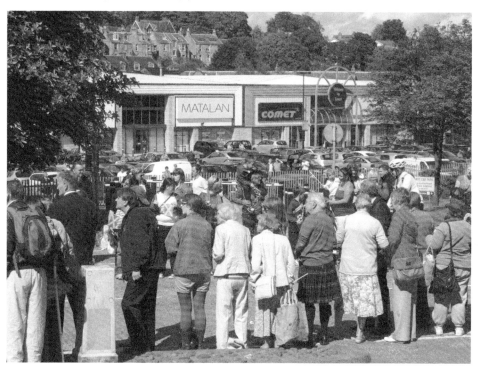

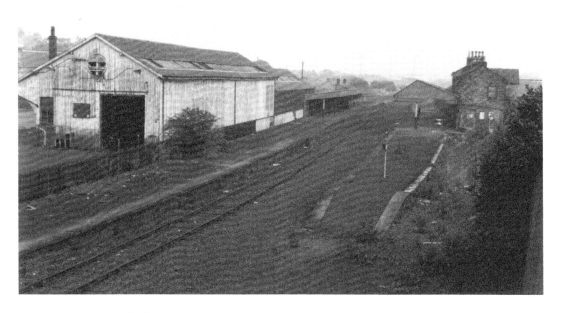

Transport Revolution

The Upper Station, like many others, was made redundant with the wielding of the Beeching Axe in 1963. This was the result of the vast extension of the use of cars and other motor vehicles as illustrated here. As we note, the site of the railway station has become a car park for the aforementioned retail park.

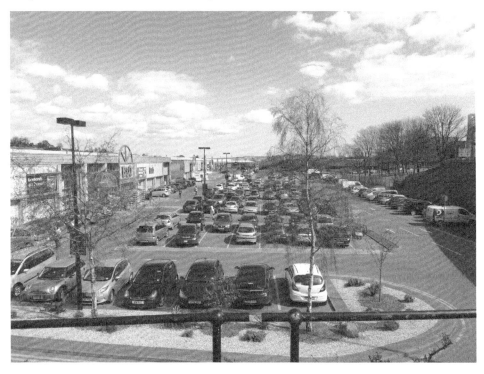

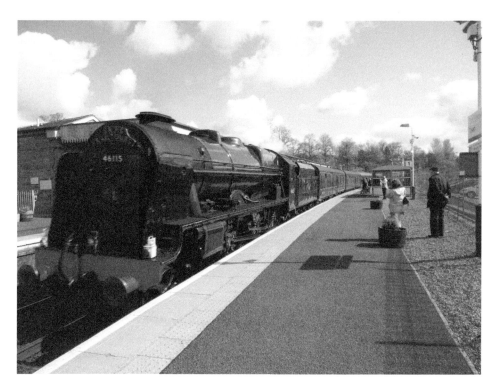

Steaming – Lower Station

Now renamed Dunfermline Town, the Lower Station was built originally for the Queensferry Line, which connected Dunfermline to Edinburgh via a dedicated railway ferryboat across the Forth. We see the station, firstly, *c.* 1950 and, secondly, in April 2012 when the *Scot's Guardsman* steamed through on a special excursion.

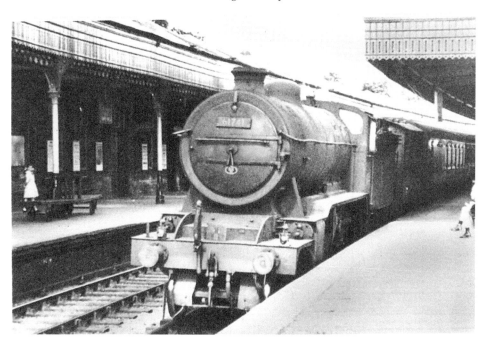

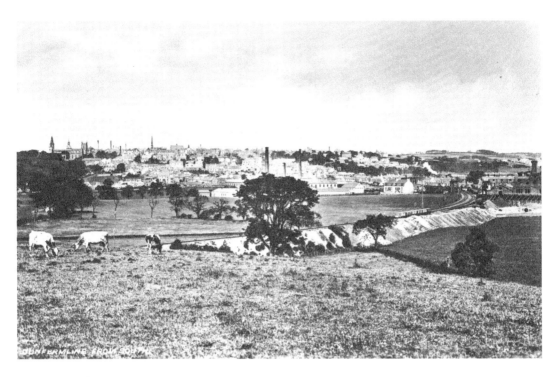

Long Views

In the early view, we see Dunfermline from the south with the railway line that led to both Charlestown and Kincardine in the foreground. The more recent long view was taken from the Gallowhill near Crossford. The abbey remains dominant but most of the big lums visible in the earlier image have gone.

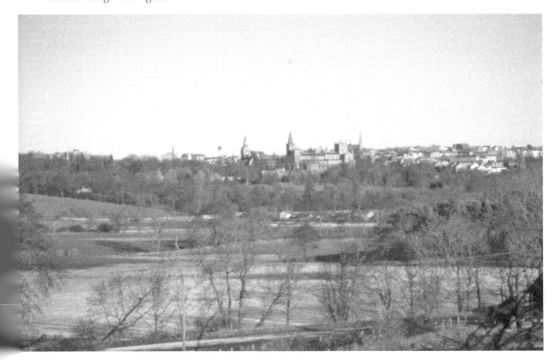

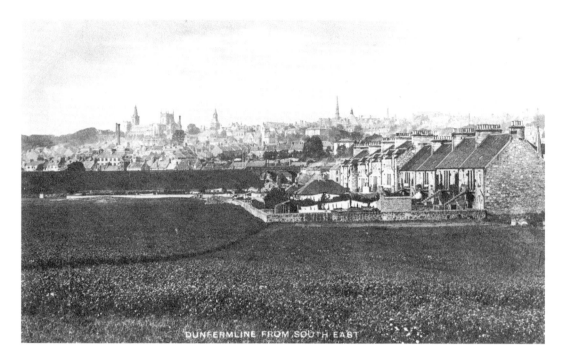

Panorama

The older panoramic view shows the rear of St Leonard's Street and empty ground where a tram depot was built for the Dunfermline District Tramway Company and which is now occupied by a bus garage. In the new image taken from the top of Hospital Hill, the Abbey, as in the earlier view, is the most prominent feature.

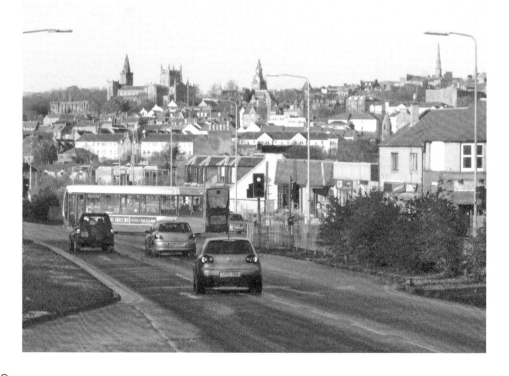

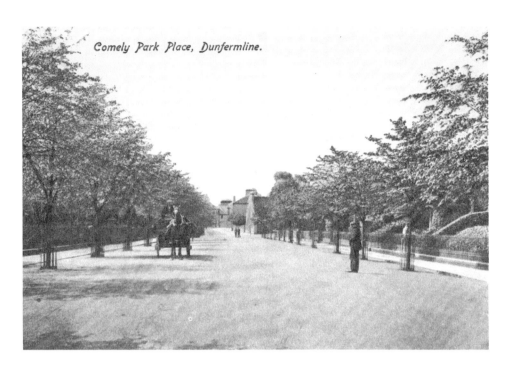

Comely Park Place, Dunfermline.

Millionaires' Row

Though the postcard is captioned Comely Park Place, the street is actually named Comely Park. Started in the 1850s, it was nicknamed 'Millionaires' Row' because the well-to-do sought to escape the more crowded town centre to enjoy more open and leafier environs. Nowadays it is used as a car park.

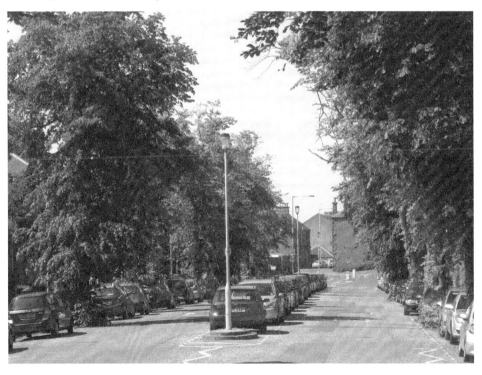

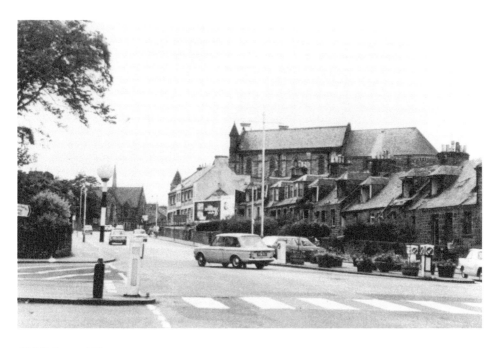

Old Holyrood Place

All the buildings on the right of the 1960s image, except for St Margaret's Roman Catholic Church, have gone. Now part of the East Port, this section of the street was formerly known as Holyrood Place. The later image shows how trees have replaced the buildings and a much changed road system.

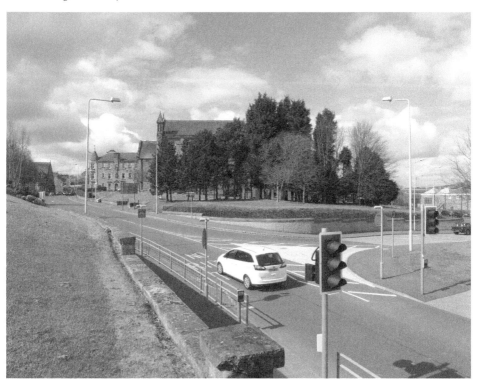

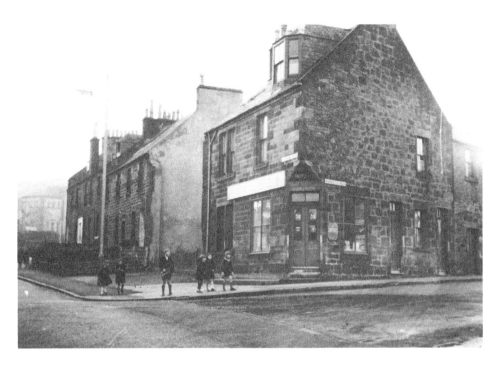

Cornered by the Police

Viewed from what is left of Holyrood Place, the police station of 1973 occupies the site of another bus garage also the corner shop shown in the older image of the mid-twentieth century. The street names on the corner shop read Holyrood Place on the left side and Market Street on the right.

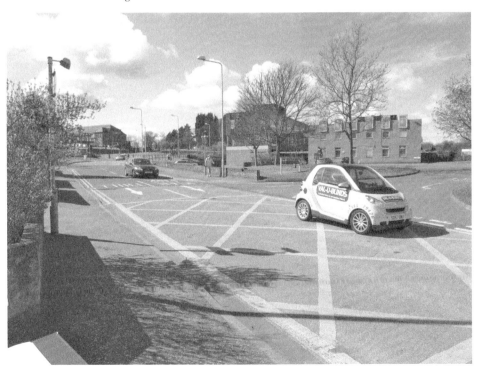

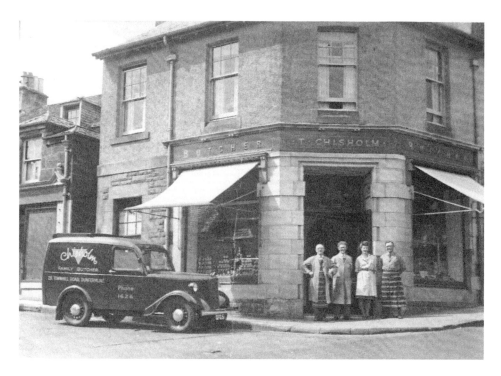

From Butcher to Plumber

Oh, for the days when we had butchers delivering from their own vans instead of online shopping. The window blinds in this Townhill Road shop would not be needed for a plumbing business.

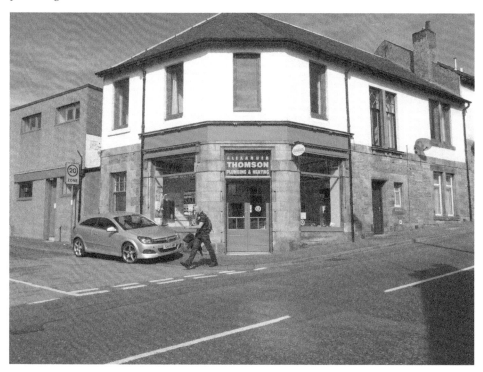

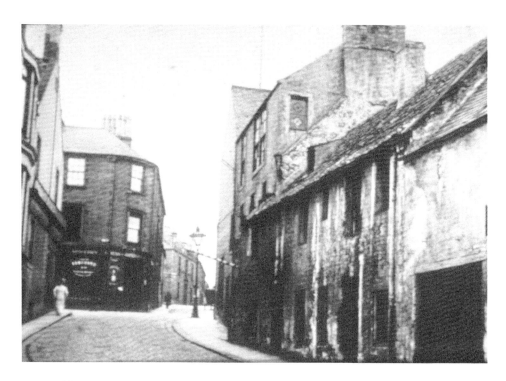

From Old to New New Row
All the buildings in the earlier image have gone. The building on the extreme right was an auction market. One of the replacement buildings bears an interesting old advertising notice, which has recently been refurbished.

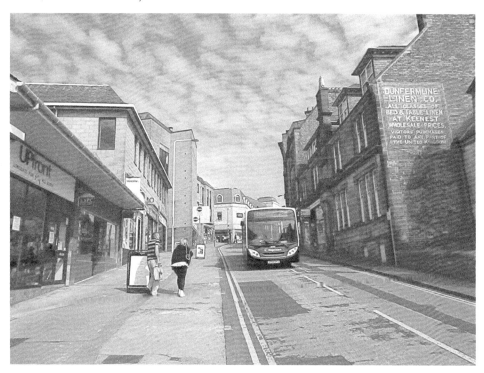

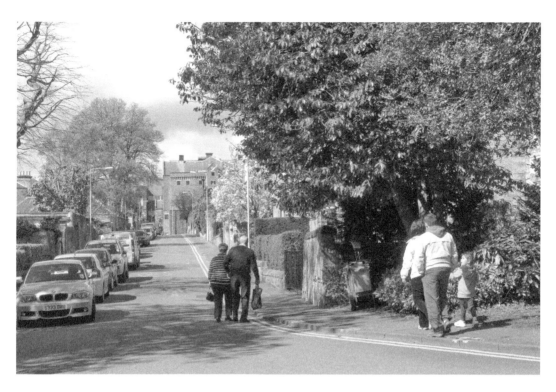

Still Leafy

Park Avenue is another of the town's residential streets. Because of wartime necessities, the railings were all removed. The Alhambra Theatre, seen in the background of the recent image, was built in 1922.

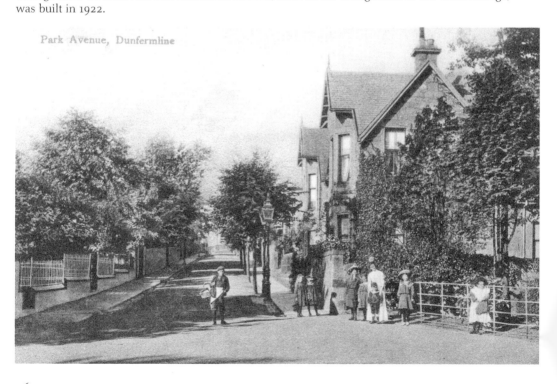

Park Avenue, Dunfermline

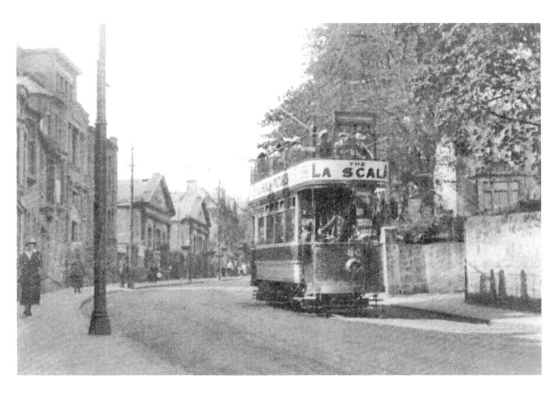

Tramway Days

The trams went down the New Row as far as Rosyth Naval Base and Dockyard. In the new image, being taken from further down the street, we see the Alhambra from a different angle. It is now a theatre again, after many years as a bingo hall and before that a cinema.

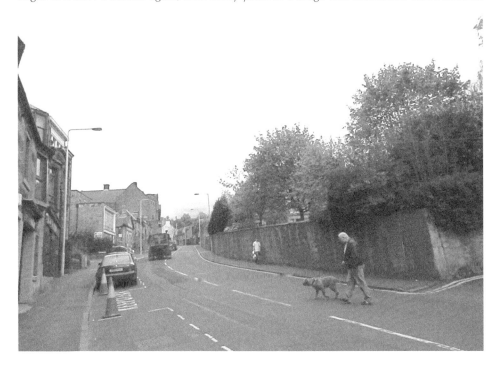

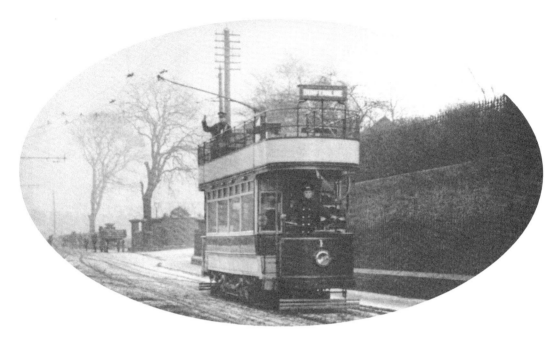

From Tramcar to Motor Car

Dunfermline's first tramcar 'No. 1' here rattles along Holyrood Place (now East Port) from what used to be known as the Park Gates, now the burgh's Sinclair Gardens Roundabout popularly known as the Magic Roundabout.

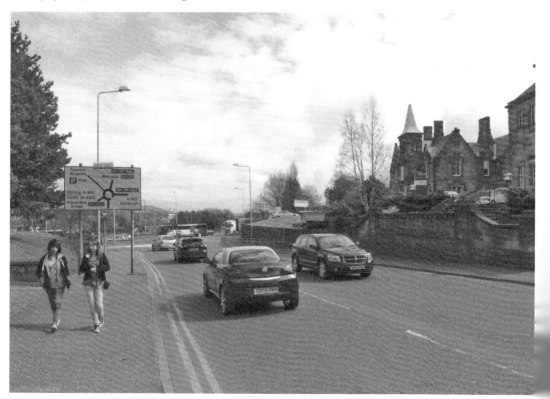

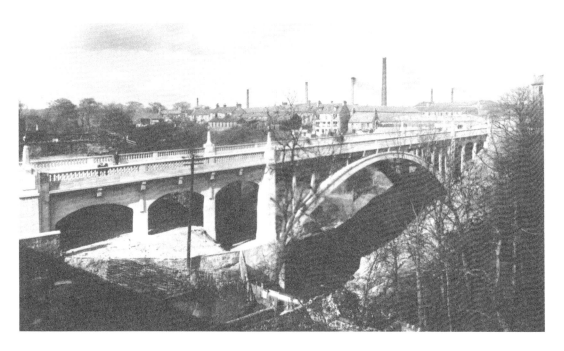

The Glen Bridge

The Glen Bridge, which crosses the Tower Burn, was constructed in 1932 to meet the needs of the new age of the motor car. Since then, the gorge has been filled in for a car park with the burn piped below.

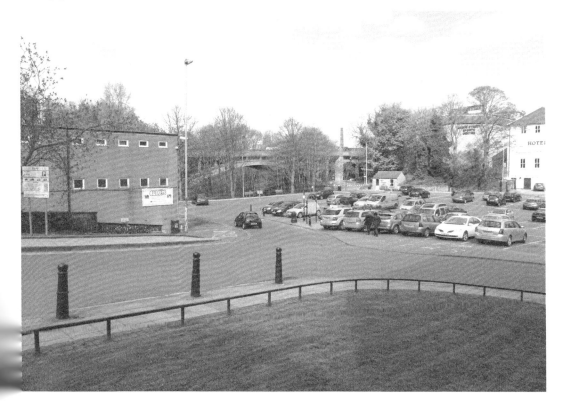

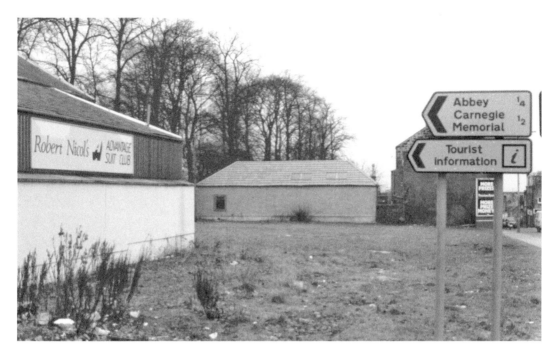

Old Loom-Shop Site

There was a transitional stage in the development of the factory system when handloom weavers were employed to work in small loom-shops instead of their own homes. The building in the centre of the old image was one such. New flats have been built on this part of Pittencrieff Street.

Macfarlane's Scrapyard

On the opposite side of Pittencrieff Street, Willie Macfarlane's scrapyard, as photographed in 1971, was a notable, if not entirely welcome, feature of the area until 1980. Nestling in the background behind the yellow crane, we observe the skylights of another former loom-shop.

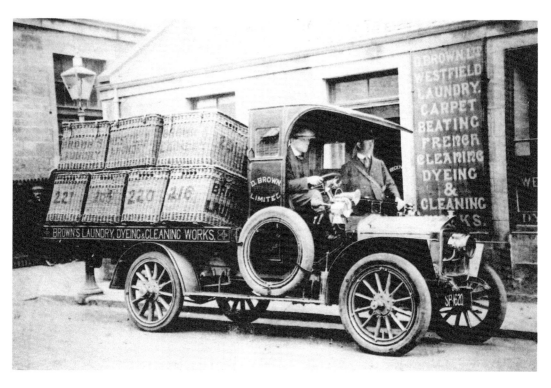

Keeping it Clean
David Brown's Westfield Laundry, *c.* 1914, boasted its own delivery vehicle, an Albion. The building on the left, as seen on the modern image of Grieve Street, houses a kitchen display area.

Golfdrum Street

Most of the buildings in the old Golfdrum Street image have gone. The street has been widened and resurfaced. Observe the contrast in street lighting.

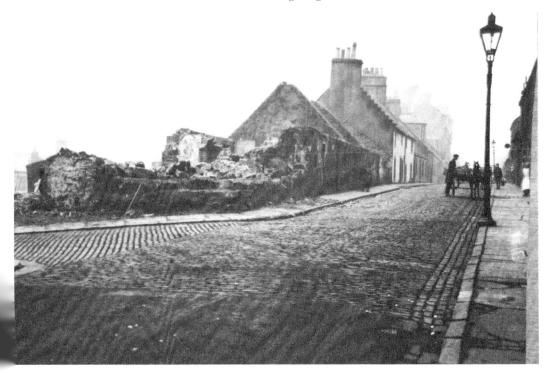

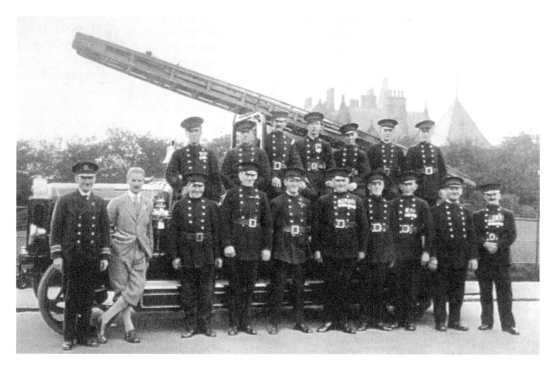

Fire Engines Old and New
The 1920s fire engine provides a marked contrast with one of today, likewise the crews' uniforms. The older engine was photographed at the top of the public park whereas the newer one was snapped in Golfdrum Street.

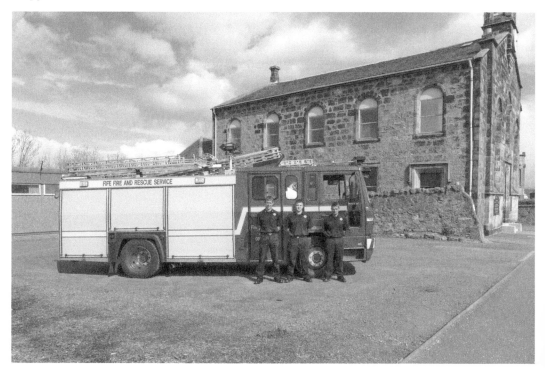

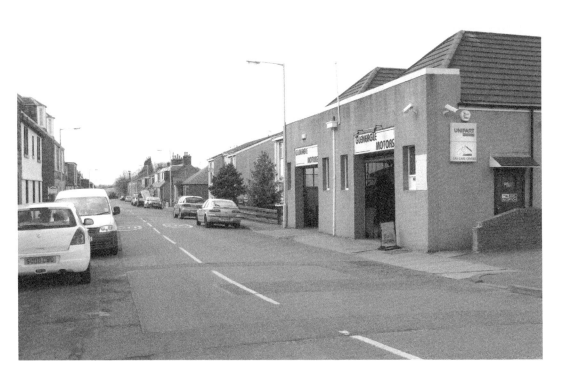

Garages

For once we have continuity of use inasmuch as there is still a garage on this Grieve Street location. Formerly Mackay Brothers car hire business, it is now Gleneagle Motors. The three storey building and some of the adjacent cottages have been replaced.

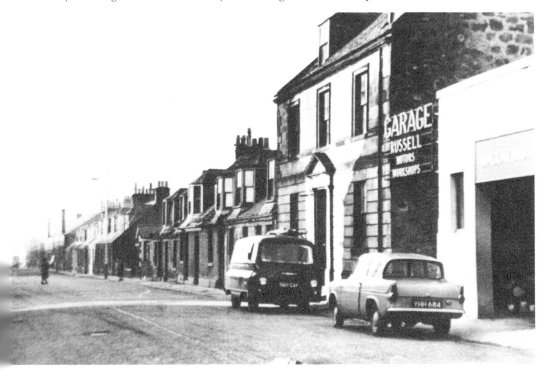

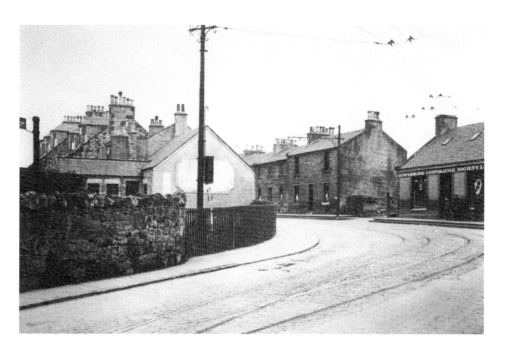

Co-op Corner

This corner at the top of William Street where it joins Rumblingwell is a totally changed scene. Virtually all the buildings, including the now defunct Dunfermline Co-operative Society's wee store, have been replaced. Note the double tramlines which provided a passing place for the trams.

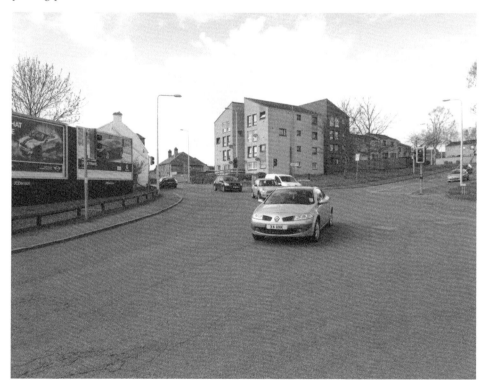

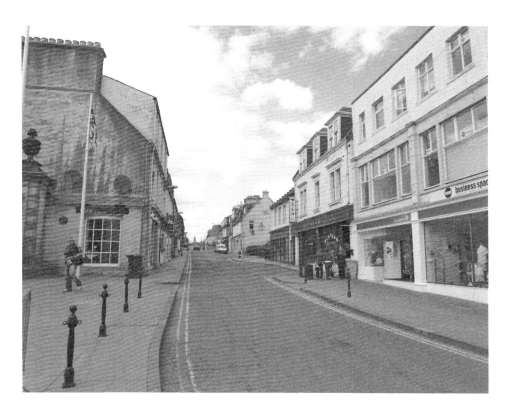

Chalmers Street

Looking north up Chalmers Street from the Glen Gates, we see a greatly changed scene. Until 1809, it was known as the Pit Path, obviously because it led to the coal pits on the west side of the town. When the church, then the United Free, on the right side of the street was demolished, the entrance to a public car park filled the gap. The burgh coat of arms adorns the postcard.

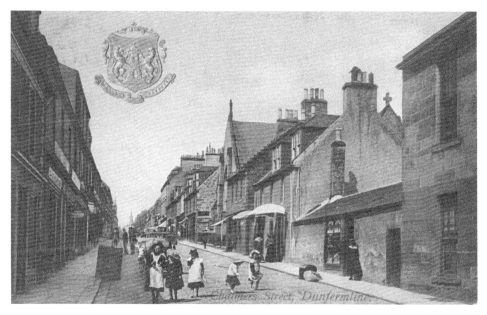

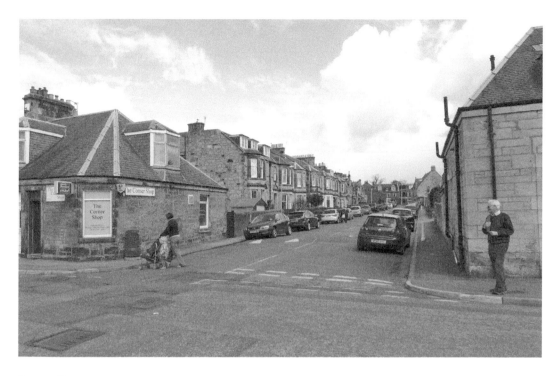

Dewar Street

To include the corner shop, the modern image has been taken from a different position. On the left side, apart from the addition of some dormer attic windows, there is little change. Though subsequently liable to subsidence as a result of old coal workings, it was built as a residential street.

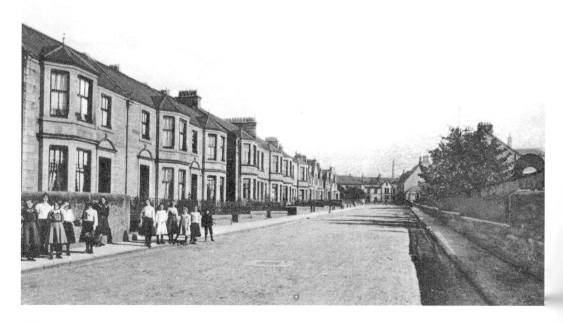

Dewar Street, Dunfermline

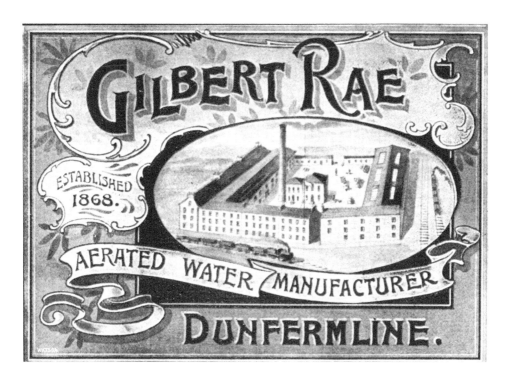

Rae's Lemonade Factory

The advertising leaflet for Gilbert Rae's aerated water factory on William Street shows an extensive works. All that is left is a block that was constructed in 1900 as housing for employees. In the inset we see the Burnett family, who are among the present day occupants.

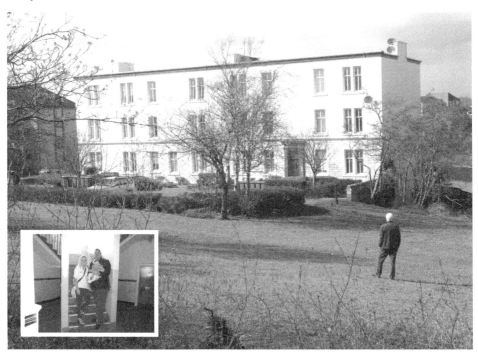

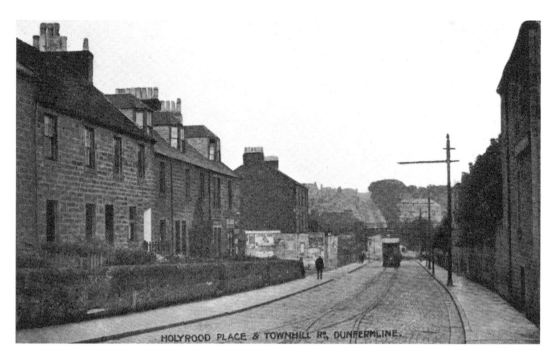

HOLYROOD PLACE & TOWNHILL R?, DUNFERMLINE.

Holyrood Place
Looking from the now demolished buildings of Holyrood Place north to Townhill Road, we see a railway bridge also now gone that carried the old Stirling-Dunfermline railway line. The remains of one of the bridge parapets is visible in the recent image.

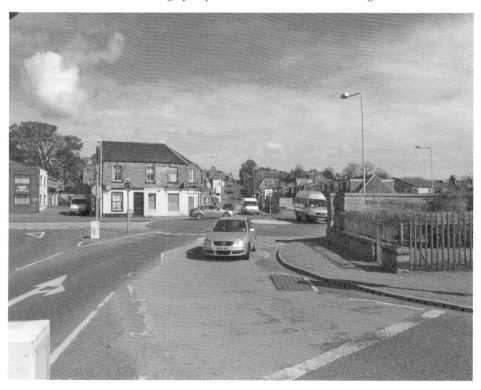

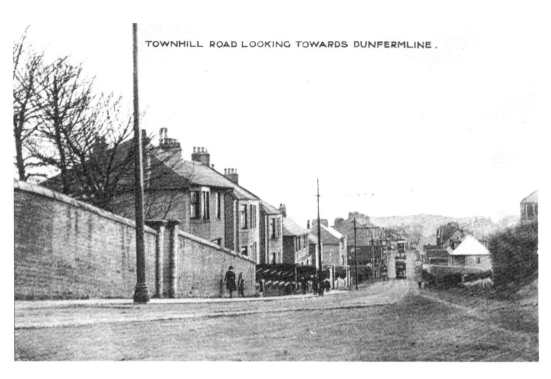

TOWNHILL ROAD LOOKING TOWARDS DUNFERMLINE.

Top of Townhill Road

Buses replace tramcars on the steep brae of Townhill Road. Apart from a few new dwellings the scene is little changed.

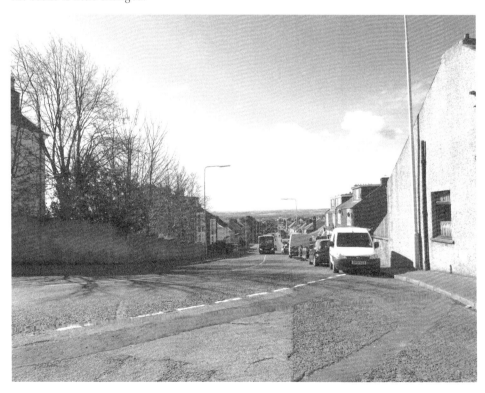

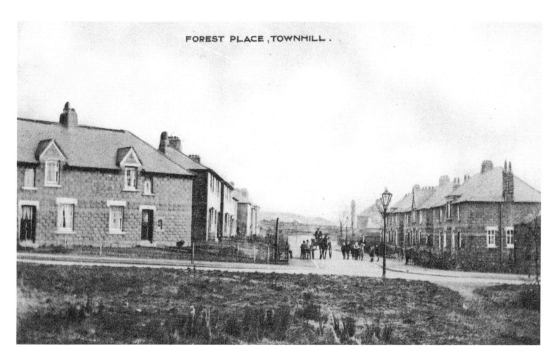

FOREST PLACE, TOWNHILL.

Forest Place

Still in Townhill, Forest Place, built in the 1920s, was one of the earliest municipal housing schemes in the area. As good quality housing, the dwellings survive mostly little changed.

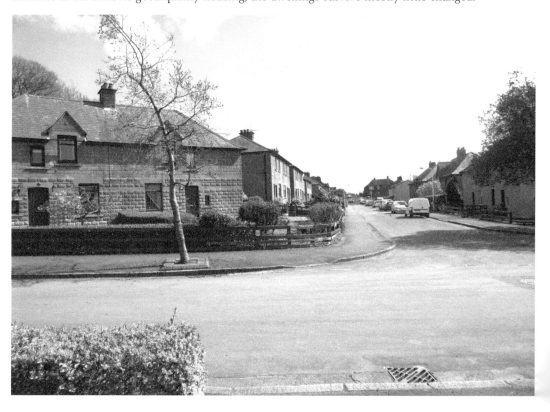

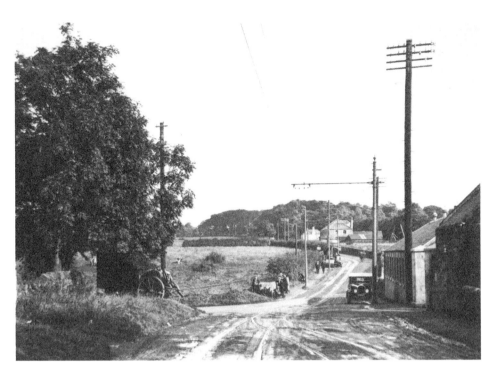

Halbeath Road

In the early 1900s, the trams from Dunfermline to Halbeath passed through a rural landscape. Now the tramlines and their power lines have gone. Touch Bleachfield was located near the present day garage.

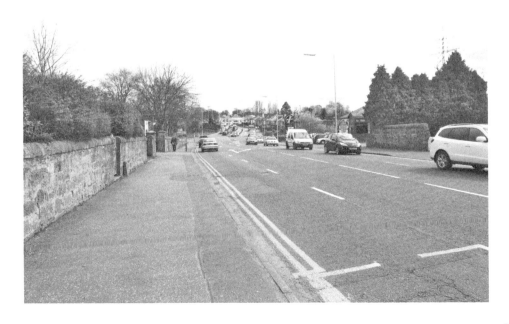

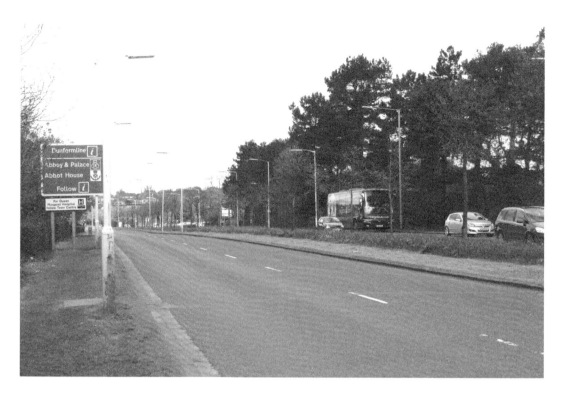

Queensferry Road

Queensferry Road was the first dual carriageway in Scotland, built in 1918 to accommodate an extension to the Dunfermline tramway system. The new line was intended to serve Rosyth Dockyard, but was closed with the rest of the tramway system in 1937.

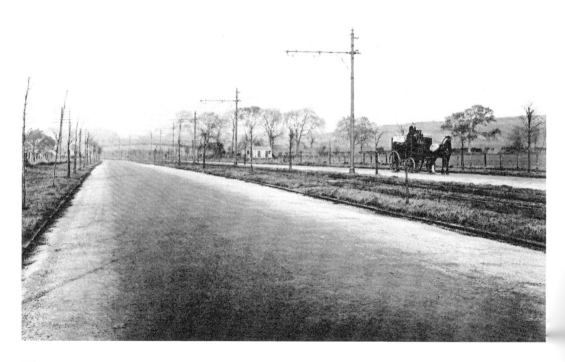

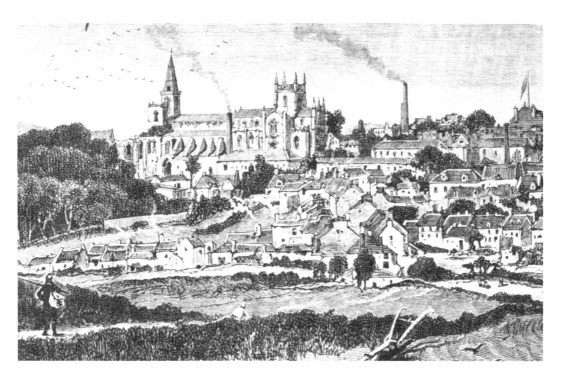

Dunfermline Abbey

The distant in time and place views of Dunfermline's splendid abbey complete this book. The Victorian illustration shows the abbey from the Grange Road area of the Auld Grey Toun whereas the recent image is taken from Hospital Hill.

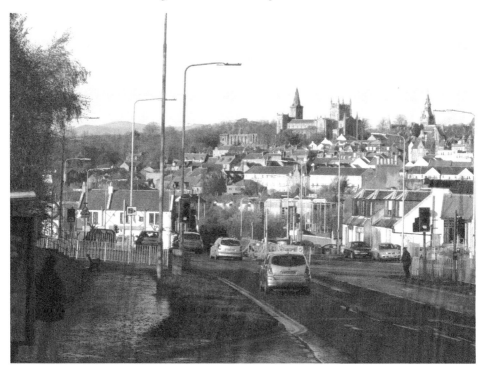

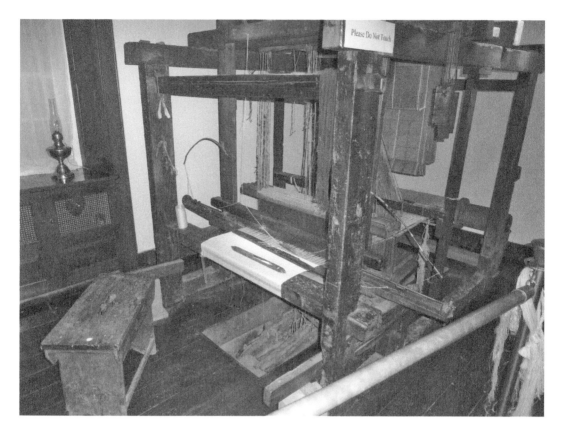

Handloom
A working linen handloom in the cottage section of the Andrew Carnegie Birthplace Museum. This is the kind of loom that would have been operated by William Carnegie, Andrew's father.

Acknowledgements

The great majority of the photographs, both old and new, are from our own archives. However, we are grateful to the following for the assistance and use of images: David Lloyd, Martin Rogers and the late Andy Lawrence.

Special thanks go to Fraser Simpson, Anne Paterson and Maureen Robertson for technical assistance and other support.

We apologise to anyone whose name we have inadvertently omitted.